Marianna

Sculpture—194 to 1996

With an essay
by Patricia Hills

and poems
by John Tagliabue

Catalogue partially funded by the
Richard Forsheim Art Fund

The Alabaster Press

Boston, Massachusetts

1996

Marianna Pineda's Sculpture

FOR MORE THAN FIFTY YEARS Marianna Pineda has developed figurative sculpture that draws on her own experiences and expresses her desire to represent universal human themes. By focusing on the female figure in the contexts of love, pregnancy, childbirth, child care, aging, and mourning, she has made concrete the abstract concept of "humankind" into tangible testimonials of the worth of people, of their pre-science, their dreams, their wisdom, and their desire to nurture, to love, and to endure.

Even at a time, the 1950s, when many of the contemporary art galleries had abandoned figurative artists, she stayed with the sculpted human form, not only because of its authoritative power to celebrate human endeavors, but also because of its potential to make moments of personal experience expressive as well as lasting and symbolic.

The themes of her sculpture have paralleled her own growing maturity as a woman, a wife, a mother, and as a compassionate and understanding individual. Early on she explored the theme of male and female love, which to her meant an equal partnership. For *Lovers*, cast in lead, and her carved teak wood, *Effigy for the Young Lovers*, she fashioned the two figures sleeping, dreaming, merging together in a timeless conjugal bed with affection and equanimity. Turning to the traditional *Leda* figure, usually represented as passively submitting to the ravishments of Zeus in the guise of an aggressive male swan, Pineda chose instead to present an assertive, resisting figure struggling against male domination.

The theme of pregnancy came naturally to Pineda, who began having children when she was twenty-one. Pineda recalls that the "sleepwalker" figures—both *Study for Sleepwalker* and *Sleepwalker*—evolved from her own situation as a woman whose life for three years had become preoccupied with childbearing and childcaring. Her *Sleepwalker* is a youthful woman, pregnant with both child and hope, gripped by the realization that her life is in the process of change. She holds her hands up in a gesture of awe and anticipation of her liminal state, as, in Pineda's words, she "feels her way toward a new mode of being." To Pineda having children and making sculpture are each creative acts—one of the body and the other of the mind and hand—and she continues to draw on the theme. Even the wood *Daphne* evolved from a small study of a pregnant *Ophelia*. To her, pregnancy is one of the most powerful and effective metaphors for the mystery of creativity.

During the three years she lived in Florence with her husband, the sculptor Harold Tovish, she frequented out-of-the-way churches and small museums. She became intrigued by the many pre-Renaissance sculptures based on the Christian theme of the Visitation: the visit of the young Virgin Mary, pregnant with the

Christ Child, and her elderly cousin Elizabeth, soon to give birth to St. John the Baptist. The beauty of a pregnant friend, together with the early sculptural examples, impelled her again to explore the theme. Unlike the pregnant *Sleepwalker* alone with her apprehensions, the older and younger women (like St. Elizabeth and the Virgin Mary) in the "visitation" series greet each other with acknowledgment of their shared, awesome destinies.

The representation of the actual birthing process—of bringing into the world the next generation—has not often been treated in the history of Western European art. But from her own experiences, Pineda real-ized the potential of birthing as a forceful trope for the dramatic moment when life produces life, when nature's processes take over and the mind defers to the rhythms of the body. *Prelude,* the subject of which is a woman in labor, evokes that metaphor. Here Pineda has generalized the woman's face and body in order to create an everywoman. Left vulnerable by the drapery slipping down onto her thighs and with her hands entwined with strips of cloth to pull against during the contractions of her uterus, she lifts her body to meet the pain that electrifies her whole being. By combining generalized forms with the speci-ficity of the psychological and physical tensions of the child-birth labor, Pineda offers us an image of a life process specific to the female sex. But her aim is not just an essentialist celebra-tion of women's life processes, but rather an evocation of the

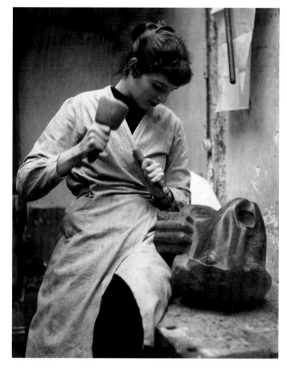

physical and mental tensions which face us all when we struggle to give birth to our ideas and creations.

The sublime themes of birth and creation have been balanced in Pineda's oeuvre by small sculptures about the domestic joys of caring for, nurturing, and watching children grow, such as her sculptures *Mother and Child Balancing, Mother and Children,* and *Reclining Mother and Child.* Not wanting to neglect the male half of the nurturing process, Pineda includes a father in the sprightly *The Dance (Father and Son).* In 1970, when developing a sculpture commission for the Boston Redevelopment Authority, to be placed in the Sum-ner Street Housing Development for the Elderly, she offered *Twirling*—two children swirling about, the image of youthful exuberance and beginnings.

Life's experiences invariably also include endings, the mourning of what has been lost—a child, a lover, a parent, a friend, or youth itself. Many of her sculptures on this theme had their origin in a specific event. *Harvest* memorializes the death of an older brother. *Two Figures (The Loss)* originated when Pineda saw a newspaper photograph of parents mourning a missing child, a child eventually found drowned. The theme of loss became generalized when, over a period of eight years, she developed her "wailing women" sculptures—done in the various media of ivory, silver and bronze. The kneeling, middle-aged nude female figure raises her arms to clasp her head, and her hair streams down her back and belly, etching into its surface like flowing tears.

In the early 1960s, while Pineda held a two-year Fellowship at the Bunting Institute of Radcliffe College, she began a series of sculptures based on the Delphic Oracle. Reading accounts of ancient times, Pineda learned that a priestess called the Pythia sat on a golden tripod over a rift in the volcanic rock, which emitted intoxicating fumes. In a trance she voiced sounds translated into prophesy by priestesses for those seeking knowledge of the future. Later these prophesies were interpreted by male priests of the cult of Apollo. However, Pineda wants to return the gift of prophesy to women. These *Aspects of the Oracle* represent the creative states, from accusative to ecstatic, rapturous, jubilant, portentous and exhausted.

Pineda has also explored the theme of the assertive woman, aware of her power and potential, in creating *Judith.* The Biblical Judith was a Jewish heroine written out of the authorized Christian Old Testament, but yet popular with Christian artists of the Baroque period of Western art who found the Book of Judith in the Apocrypha. The beautiful widow Judith smuggled herself into the enemy's camp and murdered their general, Holofernes, thereby saving the besieged Jewish city of Bethulia. In conversation Pineda admits that Judith is either a heroine or a terrorist, depending on "which side you are on." By making her Judith nude, with a *contrapposto* stance and arms akimbo pose, she was making a sly reference to Donatello's *David,* and thus giving notice that female figures are the equal of such Biblical heroes as the giant-slaying David.

Pineda's commission in the early 1980s to sculpt a statue of Queen Lili'oukalani for the Hawai'i State Capitol provided the opportunity to explore a real woman who was both authoritative and oppressed. Pineda then began her journey back through time and across place to the nineteenth- and early twentieth century Hawai'i and to the islands' last ruling monarch. The journey obviously had a goal—to represent in a permanent material (bronze) the visage and character of a noble queen for a public space in Honolulu. It was not a hasty journey, but one taken with deliberation, great respect for her subject and the Hawaiian people and, eventually, love. Pineda went about her research in the traditional method of sifting through historical evidence, pouring over faded photographs, reading Lili'uokalani's autobiography, and investigating newspaper accounts. Pineda researched the details of the intrigue of the American plantation owners and of their military takeover of the islands, and of the Queen's resistance, overthrow, and subsequent imprisonment. The

project turned out to be more than the eight-foot high sculpture for the State Capital plaza. Many and varied images in bronze, terracotta, and drawing of Lili'oukalani as a child, as Regent, and as an older, dignified ex-monarch were generated. Through internalizing her growing understanding of the Queen's character under circumstances first of glory and then oppression, Pineda was able to restore to the Queen the dignity and respect that Lili'oukalani currently commands from the Hawaiian people. What marks these images of the Queen is their expression of powerful composure and the aura of timelessness that surround them. *The Spirit of Lili'oukalani* has become the site of many demonstrations, and hence, a vital presence—capable of inspiring both contemplation of the past and future action for the Hawaiian people.

Pineda knows that women have not always been able to rise up from intolerable situations. Throughout her career she has thought about women beaten down by unbearable circumstances not of their making. *The Dance of Sleep or Death*, 1953, came into being when Pineda became aware of the increasing number of homeless people in American cities. And *Defendant*, 1986, was inspired by a newspaper photograph and article about an abandoned woman who had inadvertently drowned her two infants.

Pineda continues with images of strong women, particularly the "Eve Celebrant" series, begun in the late 1980s. A maquette for a competition and *Life Study*, sculpted from a living model—an African American scholar and friend—generated the idea of Eve, of a first woman, with African features. In art history her Eves recall Egyptian sculpture of the early dynasties and the images of the walking pharaohs and their static, standing female companions. Pineda, in fact, defies this tradition by having her women glide through space. Each variation consists of a nude and a draped version: *Nile Valley* depicts a pregnant woman, fertile as the Nile that nurtures a large part of Northern Africa; *Serengeti Plain* images a walking woman who both offers the fruit of knowledge and also holds up her hand in caution; *Dance of the Matriarch* represents an older woman dancing with her arms held high. The culminating, seven-foot tall *Eve Celebrant* has a face and body that incorporate the features of many races. They are active walking figures, serene in their self-possession, representing wisdom, creativity, compassion, and authority—appropriate presences to have in our midst. What marks Pineda as unique among modern sculptors is her ability to infuse universal themes with a specificity that gives them a contemporary urgency.

—*Patricia Hills*

Early Work

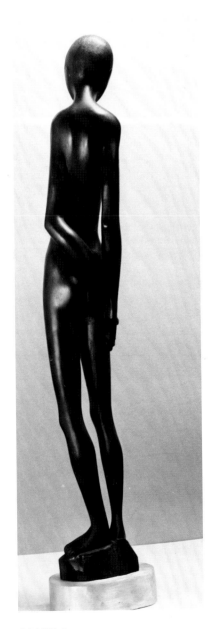

PLATE 1
Black Figure

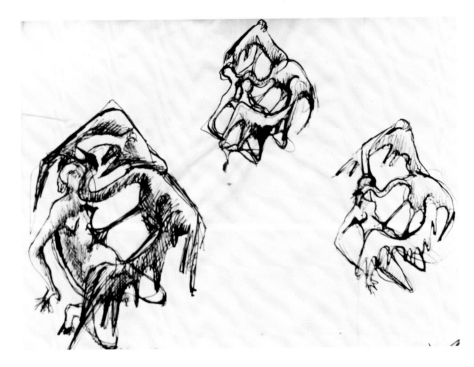

PLATE 2
Study for Leda and the Swan

The concept for the Sleepwalker came
to me at a time when I had been three
domestic years away from my sculpture,
when I despaired of finding my way
back into creative work. The theme
obviously derives from life experience:
the child-woman feels her way towards
a new mode of being. It can also be
seen as a metaphor for the mystery of
creativity.

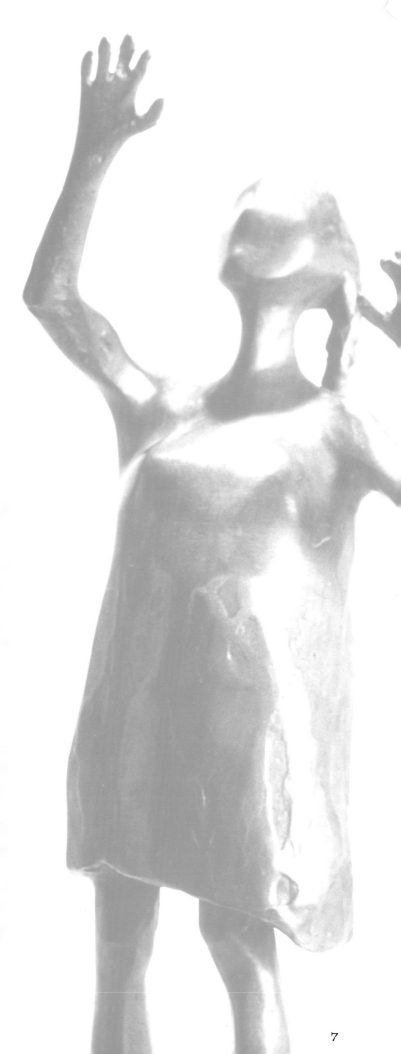

Later I began to see how many of my female figures—loving, pregnant, birthing, nurturing, prophesying, dreaming, aging, mourning—are consonant with women's new awareness of what their roles have been and what they might be.

—MP

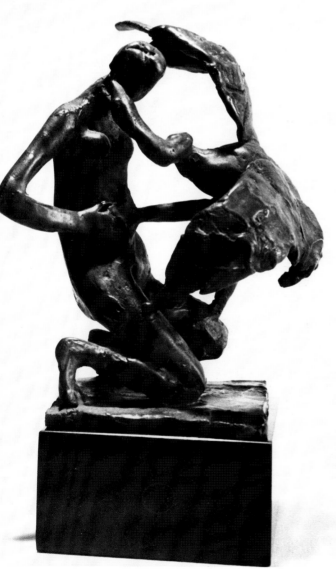

PLATE 3
Study for Leda

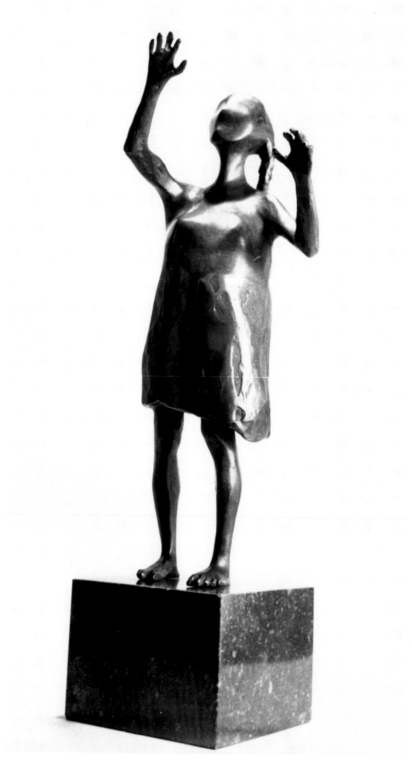

PLATE 4
Study for Sleepwalker

The Sleepwalker

The sleep walker

the deep walker

urged to feel the night air

to move as the child in the womb

 moves its

body to touch the universe to say let

 me be in

your world to look at you who slept

 and awoke

once the womb of your mother, way back

 to the

first Eve, my needs and feelings are not

 blind,

but in this dangerous world I walking knowing

 that the

chance to see your eyes and the moon and stars

 and the

daytime miracle of world and birth might be

 missed,

I walk tentatively, I feel the air, read its

 messages,

I have a calling, I hear music that is

 distant,

I believe my future child is the musician

 saying walk,

 talk to me,

 listen.

— John Tagliabue

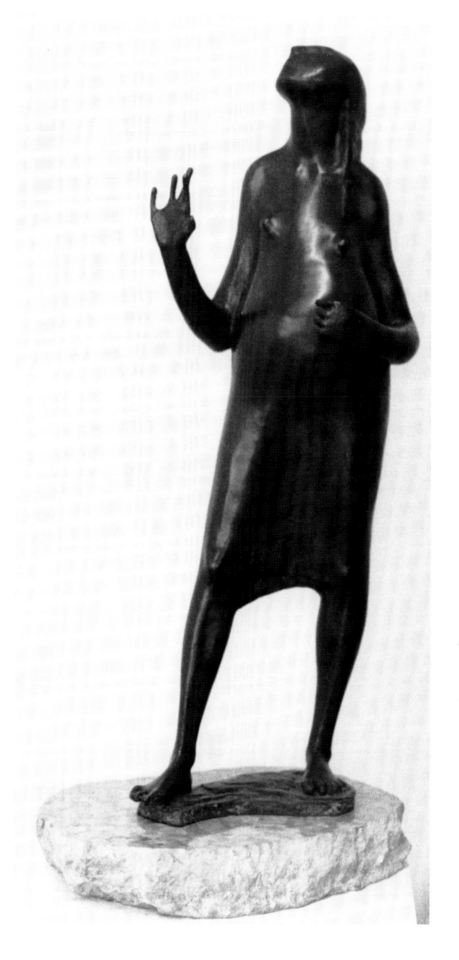

PLATE 5
Sleepwalker

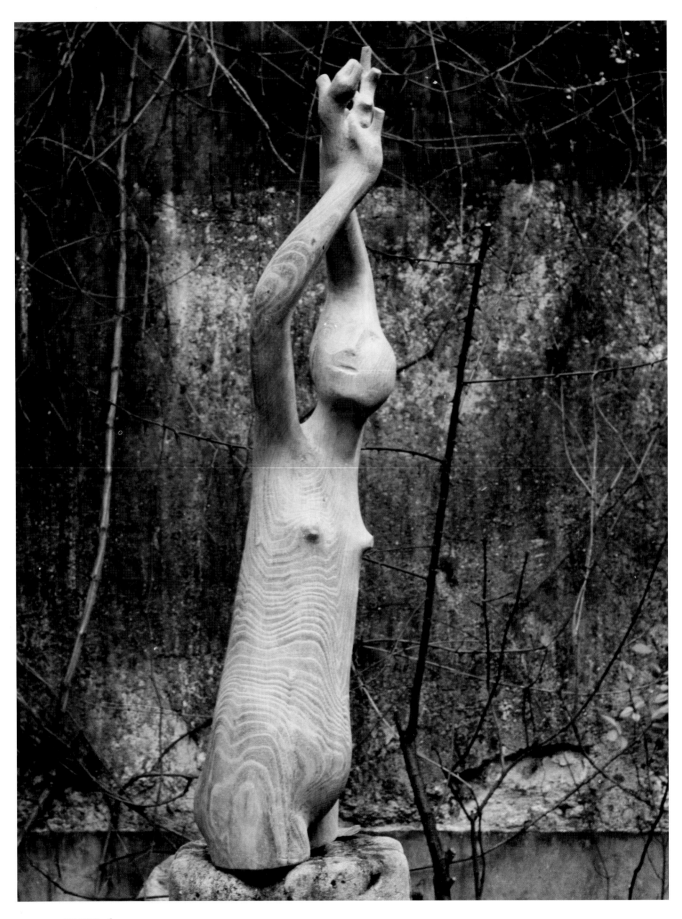

PLATE 6
Daphne

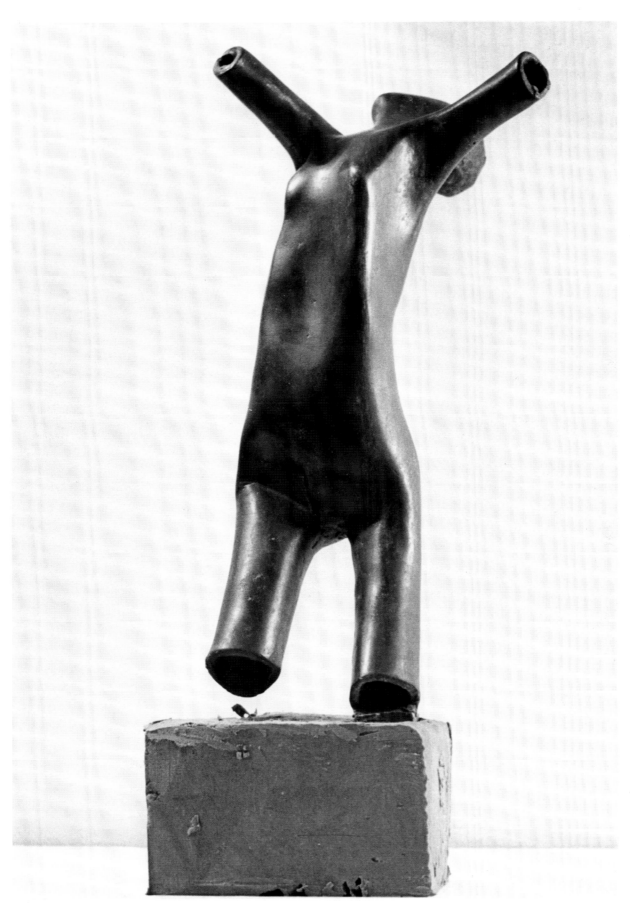

PLATE 7
Torso

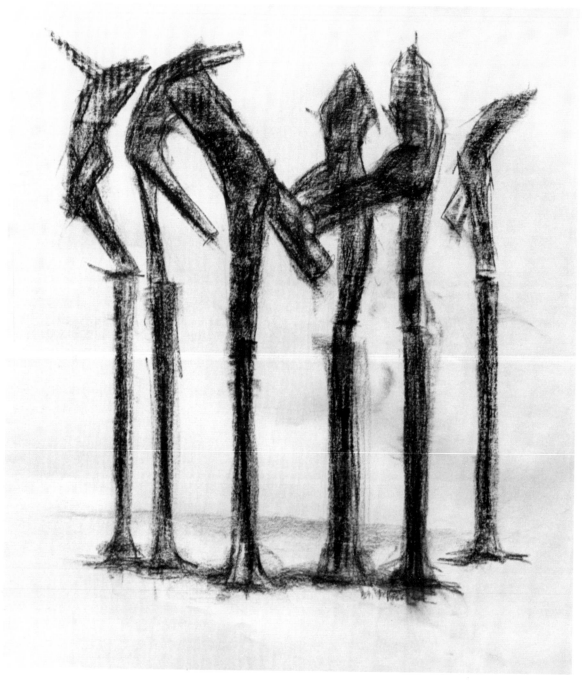

PLATE 8

Study for the Grove: Undifferentiated Energy
(Double Torso)

The Double Torsos intend to convey the
undifferentiated energy of the young. I
plan to mount these figures on tall tree
trunks to make a Grove of energetic
joyous forms. —MP

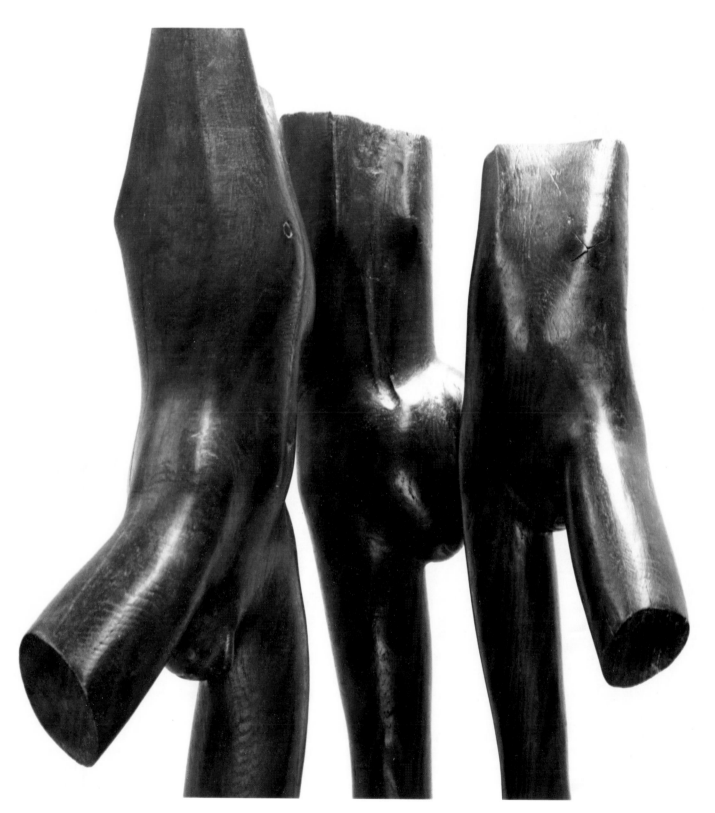

PLATE 9
Double Torso 1, 2, 3

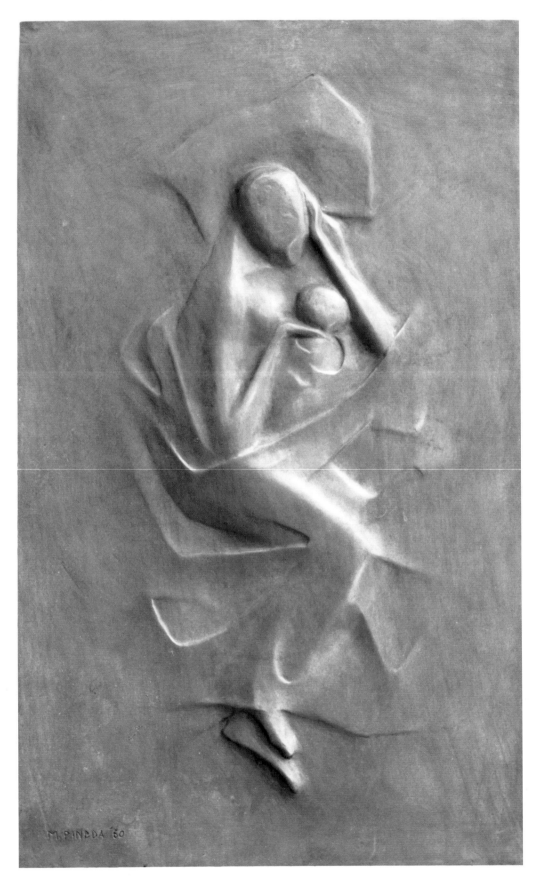

PLATE 10

Mother and Child No. 2

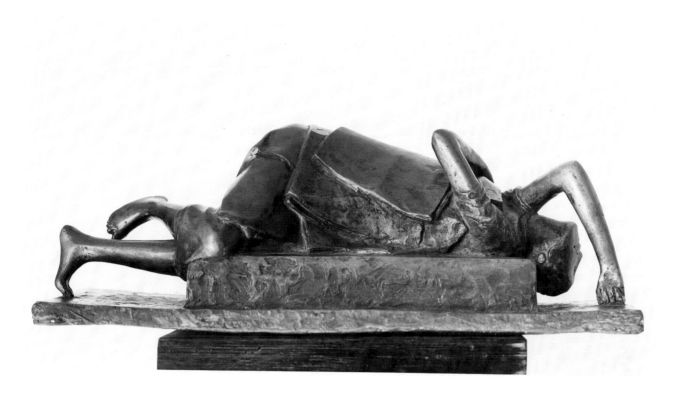

PLATE 11
The Dance of Sleep or Death

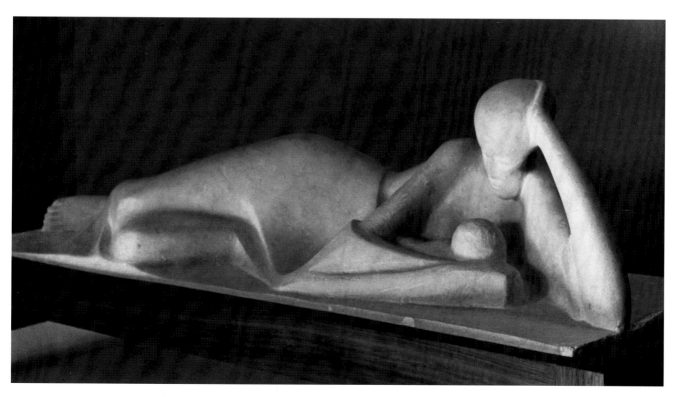

PLATE 12
Reclining Mother and Child

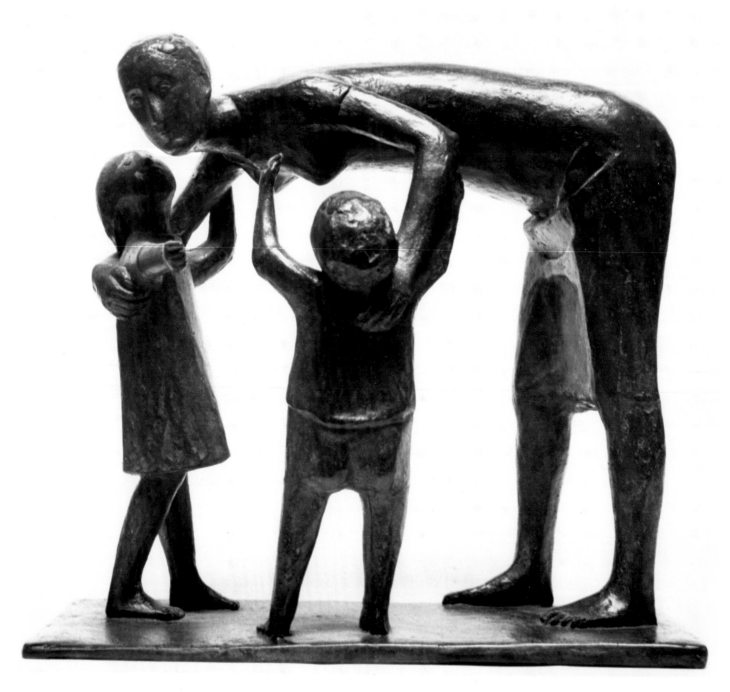

PLATE 13
Mother and Children

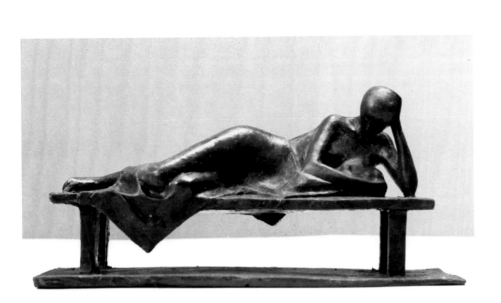

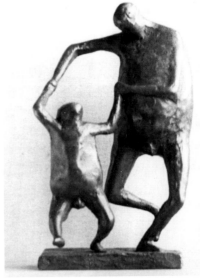

PLATE 15
The Dance (Father and Son)

PLATE 14
Reclining Mother and Child

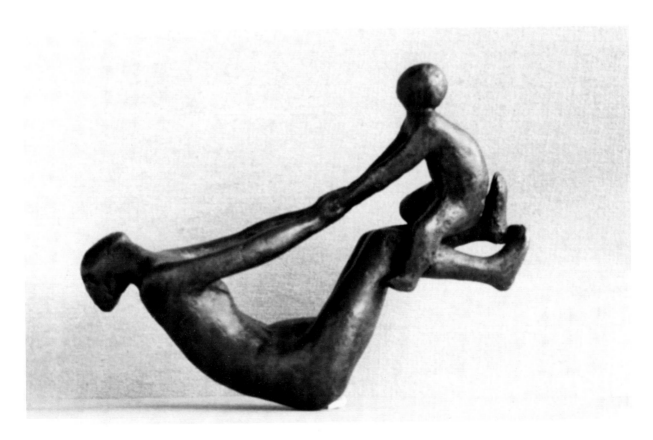

PLATE 16
Mother and Child Balancing

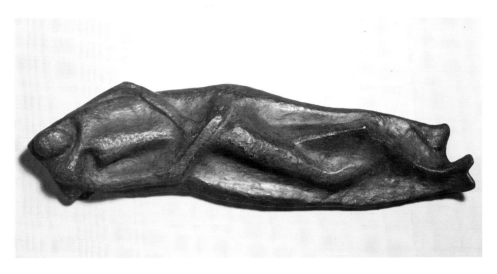

PLATE 17
Lovers

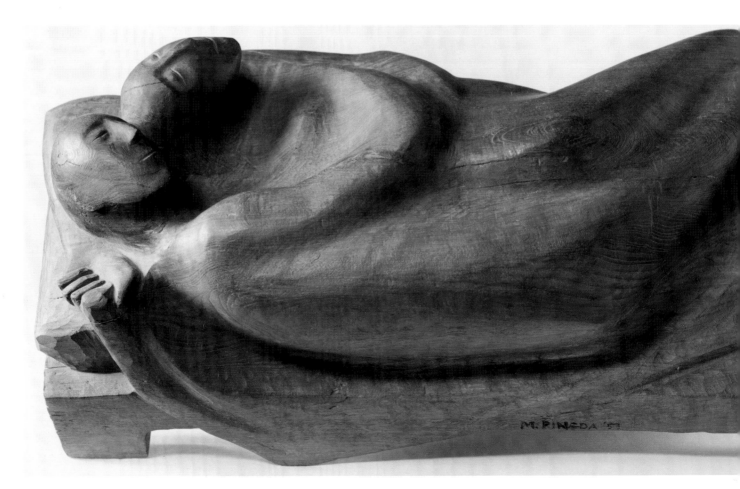

PLATE 18
Effigy for the Young Lovers

Thankful for the thoughts
of the "Winter Sleepers"

The young and old

in one another's arms (who is

 protecting

whom?) it is a chiaroscuro that

 we are in,

it is both light and darkness that

 our one

 flame flickers in; what is more famous

 than our

enrapture? a long life, elongated; we

 help keep

each other warm? what's going on out there in

 winter in

Boston and in Bosnia? a protected love, beginner

 of all flames

keeps us afloat. age cannot wither, nor custom stale

 our infinite

variety. some galaxies are drifting apart, but

 for the

time being in our united art and mystery we say

 come closer.

—John Tagliabue

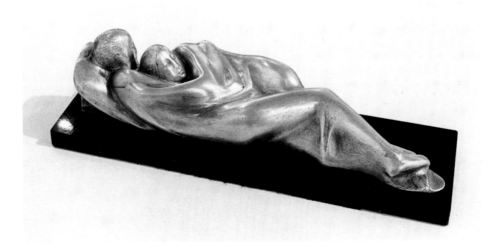

PLATE 19
Winter Sleepers

Protect and Continue

Harvest

one Mother

is a whole field of farmers

we bow to the ground we are mystics

 with sound

we listen the Mother gathers up

 the sleeping child

the lover lifts the sick soldier from his

 dazed century

the saint bows to the man from the cross

 who wishes to

walk we gather the wheat we

 gather the

whole brilliant field and we must harvest

 celebrate

— *John Tagliabue*

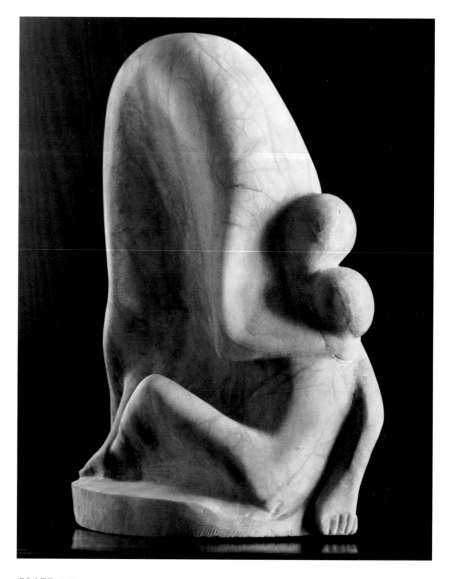

PLATE 20
Harvest

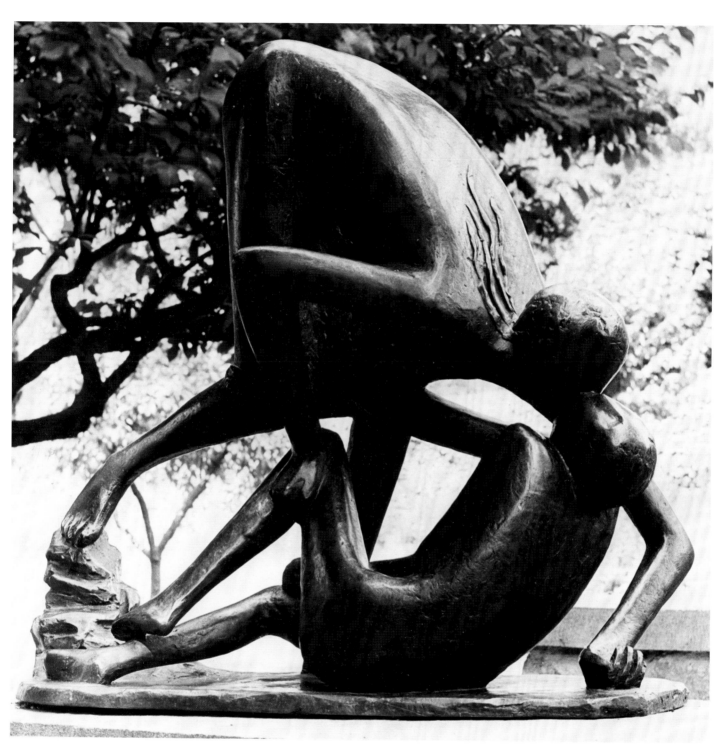

PLATE 21
Harvest

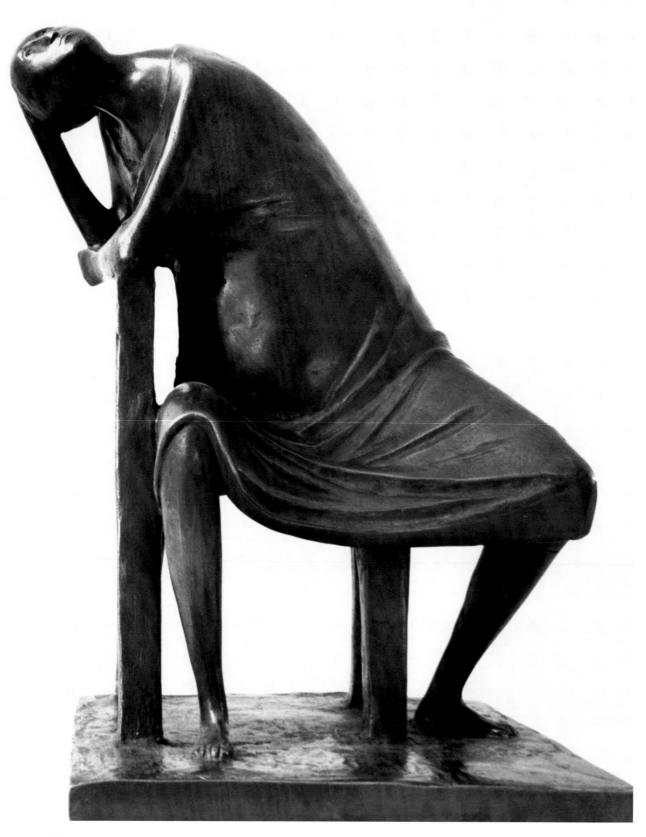

PLATE 22
Seated Woman
(The Old Dancer)

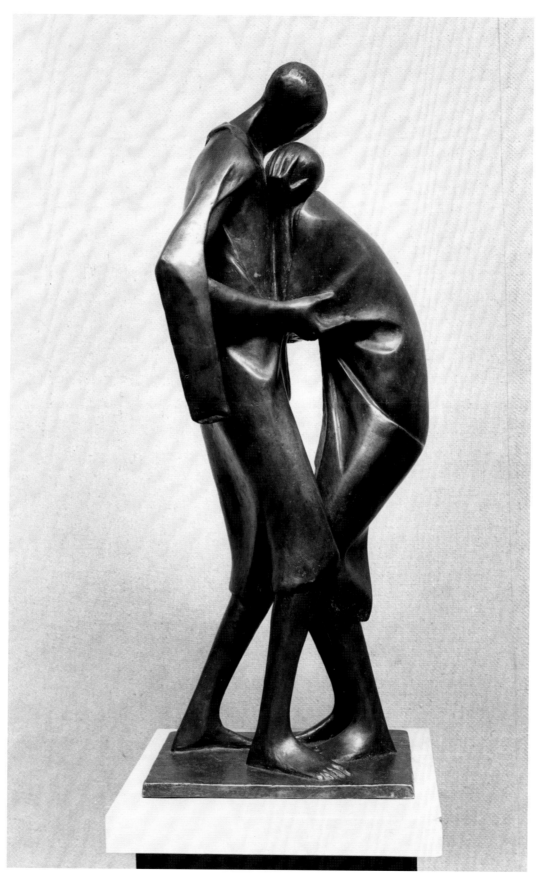

PLATE 23
Two Figures (The Loss)

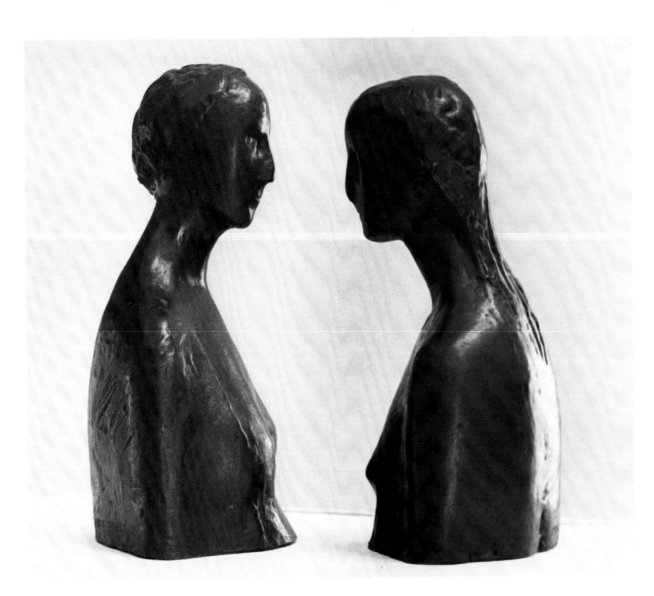

PLATE 24

The Conversation (from *The Visitation*)

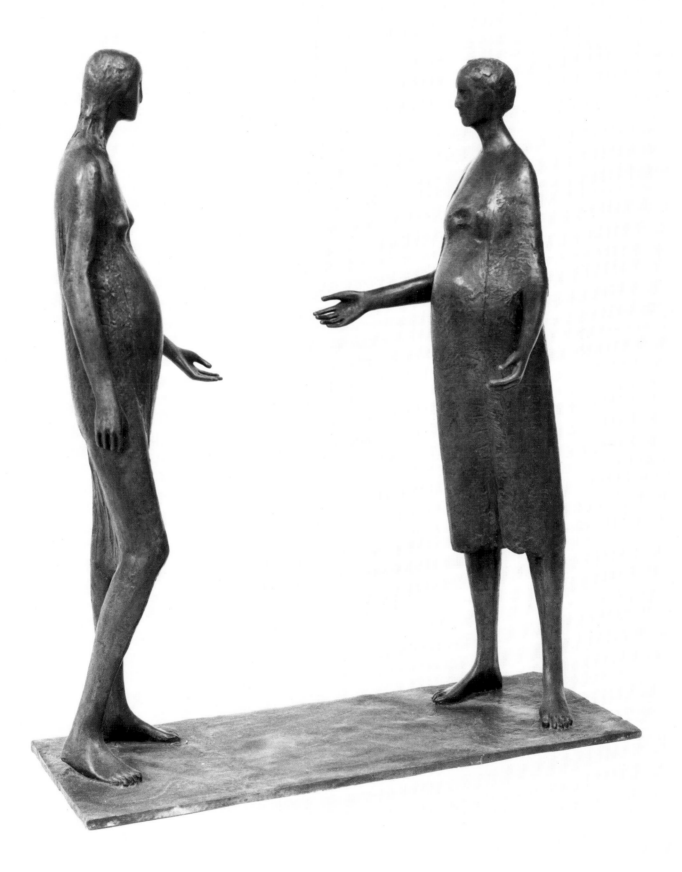

PLATE 25
The Visitation

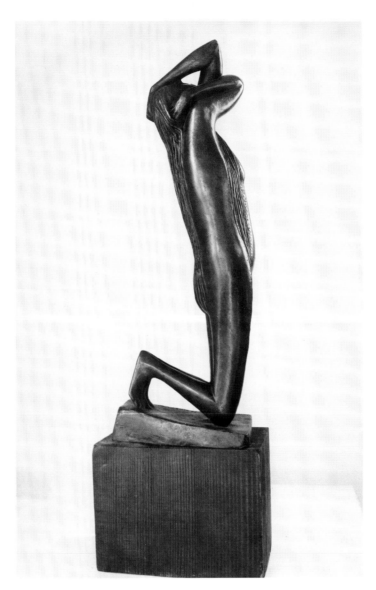

PLATE 26
Study for Woman Wailing

WOMAN WAILING

The inspiration for the title comes from Coleridge's Xanadu: "Woman wailing for her demon lover." However, this figure could be a Niobe, or a Magdalene— any no-longer-young woman grieving.

—MP

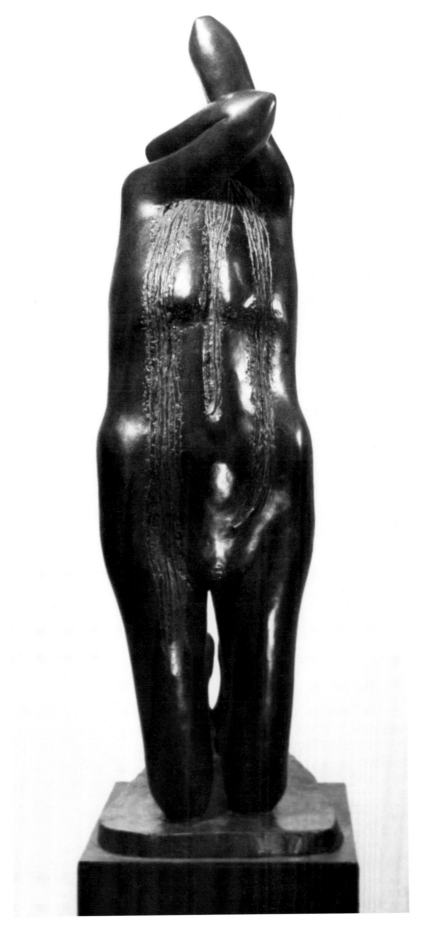

PLATE 27

Woman Wailing

I find it astonishing to note that
throughout history only a few cultures
have granted dignity and reverence to
woman as creator. Except for the Cult
of the Virgin and some African soci-
eties, the pregnant female form has
been generally taboo; an indication
of its unspoken power perhaps.

—MP

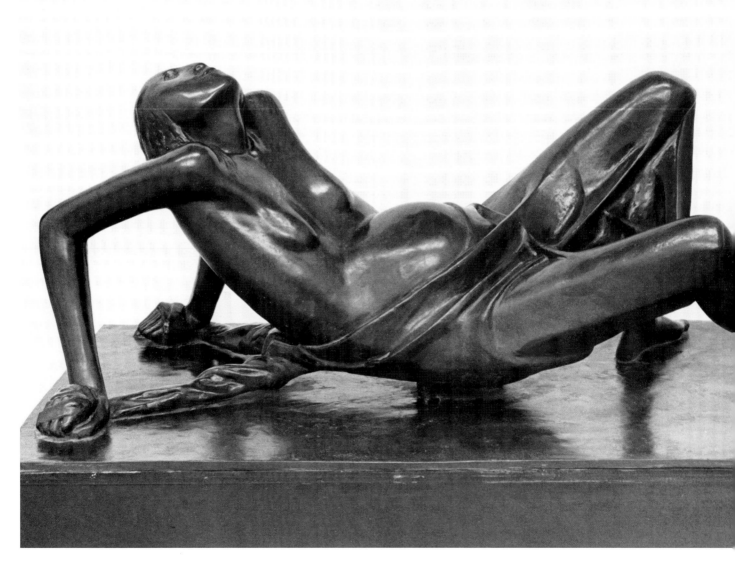

PLATE 28
Prelude

28 EARLY WORK

PLATE 29
Dancer

The Oracle Series

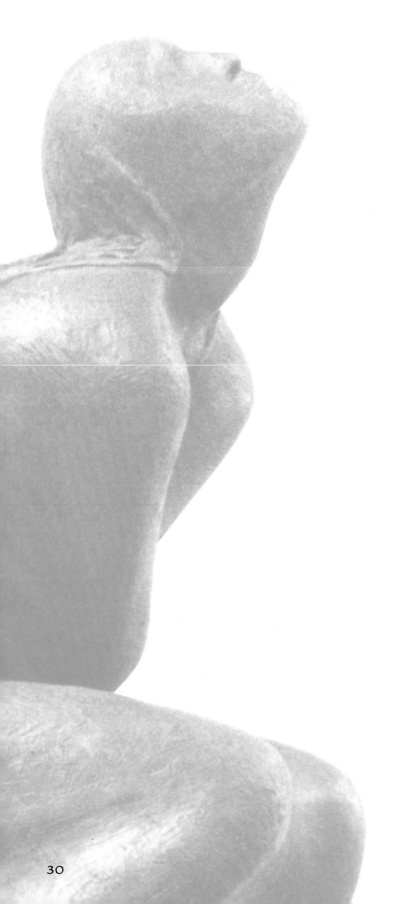

Aspect of a Possibility or
A ready reader sees/hears the highseated huddled
Rapturous Oracle

I am

Here

holding to myself for

dear life, intense in me,

particular, a project called a

miracle, could be projected impelled

toward a star, empowered to be a sparkler

in the night, holding on to something for dear cosmos,

I come like a bundle of poems ready,

propagate mysterious futures, if

you follow the missile of my

aspiration, knowledge, you

will also be rapturous,

a ready oracle

— *John Tagliabue*

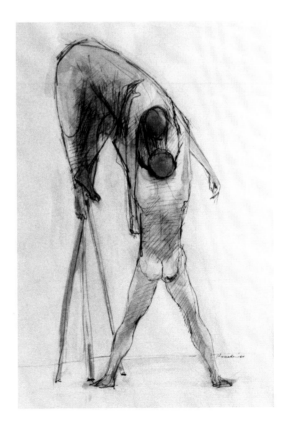

PLATE 30
Removal from the Tripod

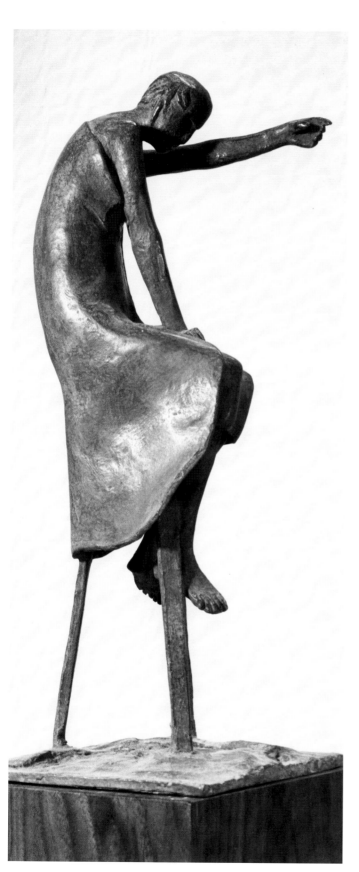

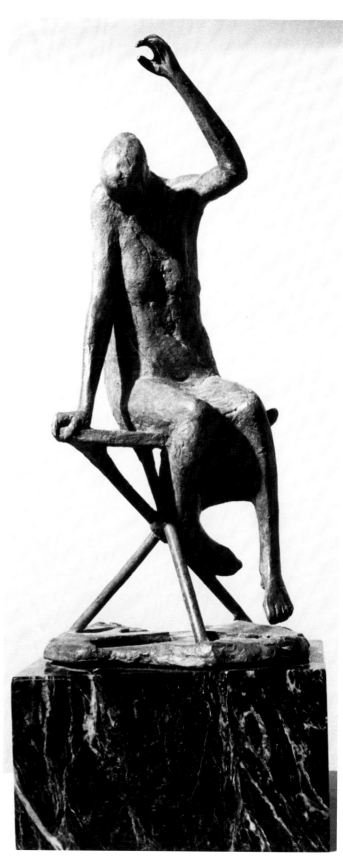

PLATE 31
Study for the Aspect of the Oracle: Accusative

PLATE 32
Study for Aspects of the Oracle: Portentous

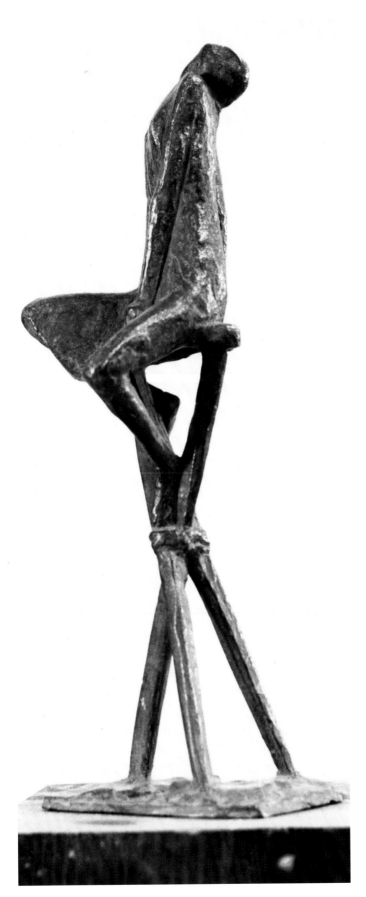

PLATE 33
Study for Aspects of the Oracle: Ecstatic

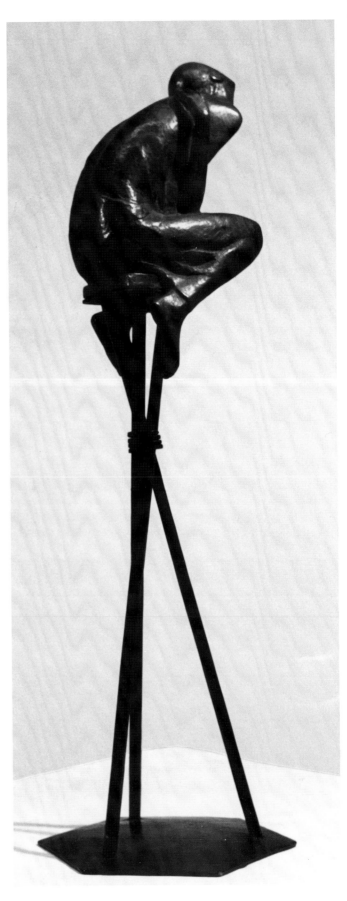

PLATE 34
Study for Aspects of the Oracle: Rapturous

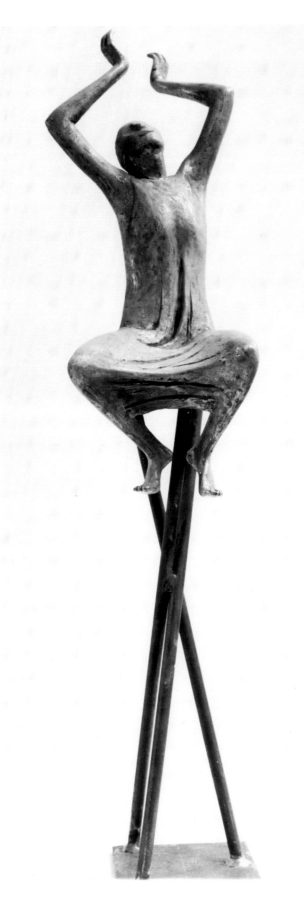

PLATE 35
Study for Aspects of the Oracle: Jubilant

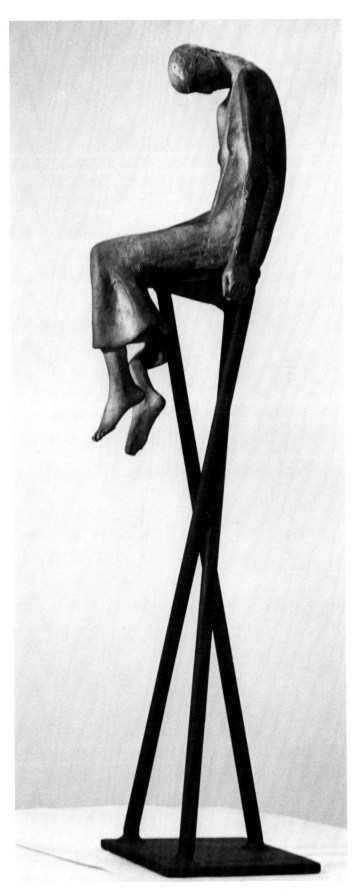

PLATE 36
Study for Aspects of the Oracle: Exhausted

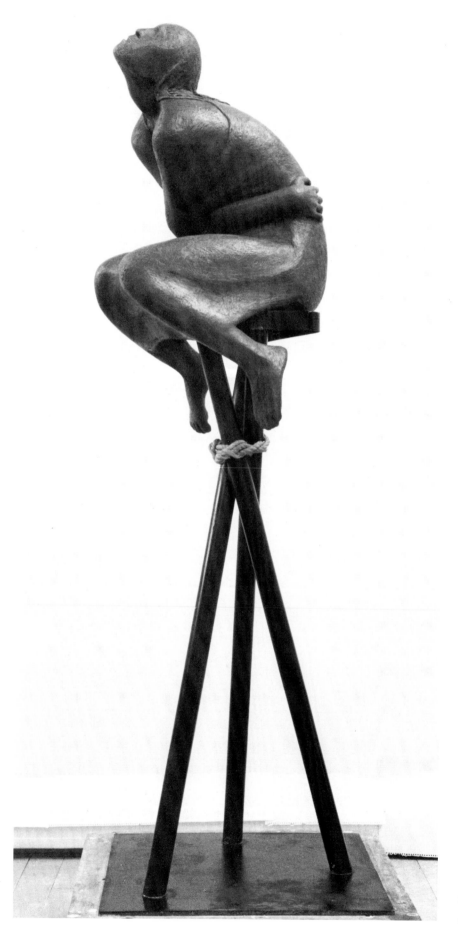

ASPECT OF THE ORACLE: PORTENTOUS

Derived from the series on the Delphic oracle, Portentous *can be viewed as a metaphor for women of vision and authority, gifted with the power of communication. Here she prophesies, drawing inspiration from the fumes rising from the volcanic rift beneath the traditional tripod—a message, perhaps, from our still-mysterious environment.*

—MP

PLATE 37
Aspect of the Oracle: Rapturous

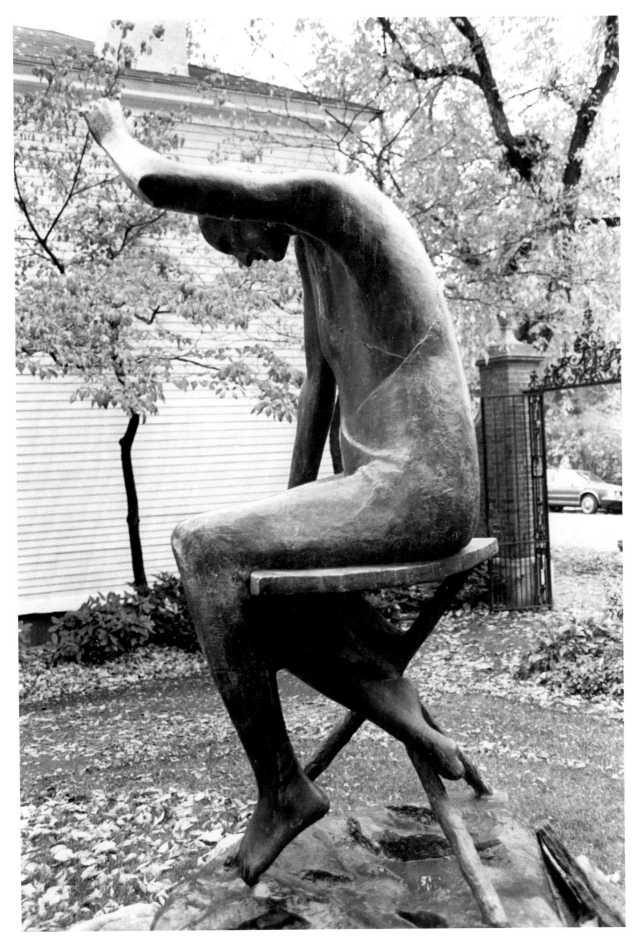

PLATE 38

Aspect of the Oracle: Portentous

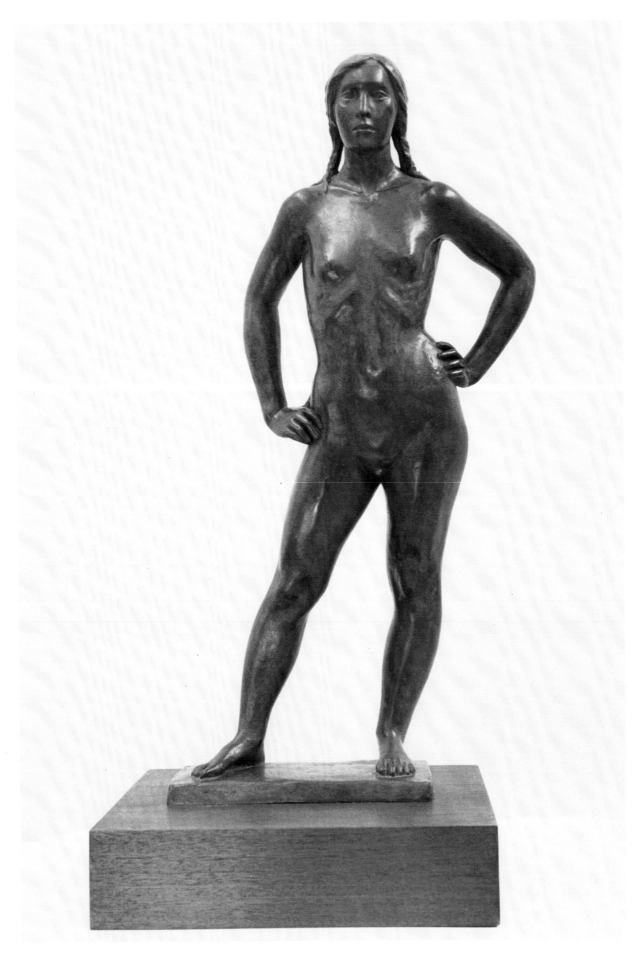

PLATE 39
Judith

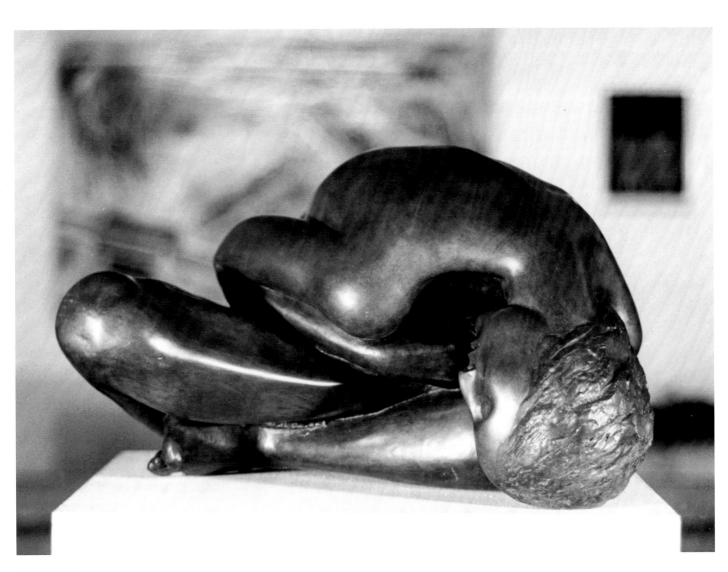

PLATE 40
Resting in Half Lotus

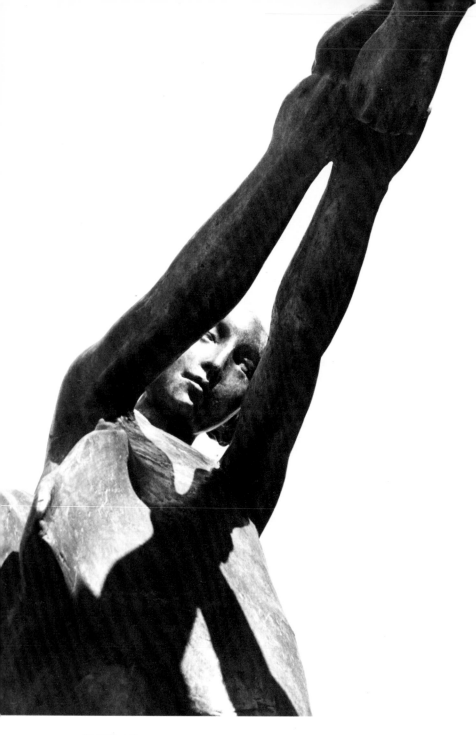

PLATE 41
Twirling (detail)

"Twirling"

Whirled into

the spinning world like delicate

and

vulnerable planets, two young girls are

holding hands;

feet to feet, freshness and elation to

freshness and

elation—capable and twirling, pensive

and at play,

daughters of Wonder and Air they form

a V,

high symbols of a to be protected

victory.

—*John Tagliabue*

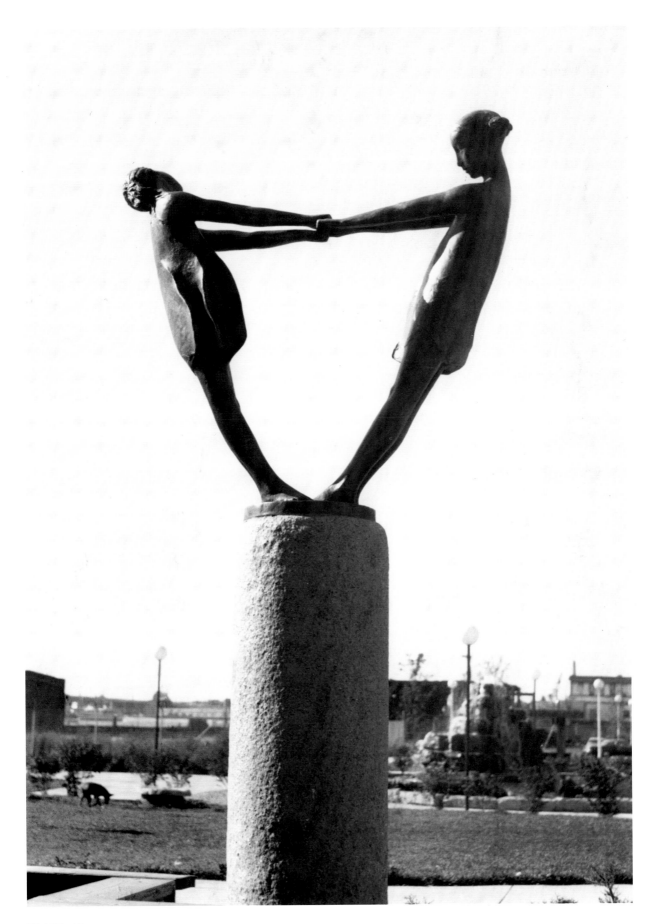

PLATE 42
Twirling

The Search for the Queen

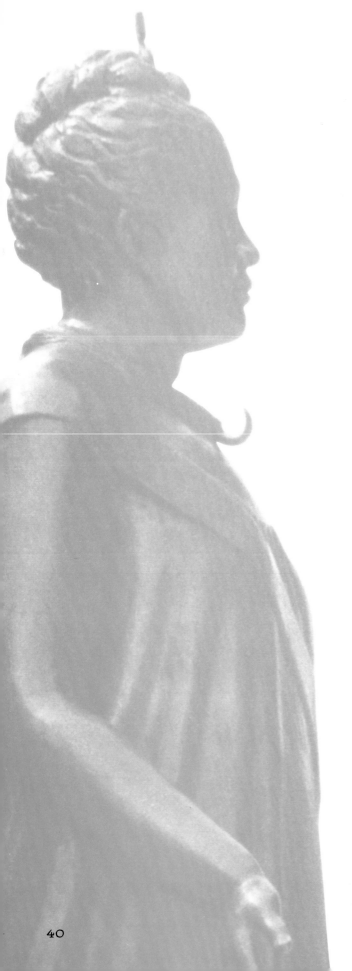

THE SPIRIT OF LILI'UOKALANI

This competition maquette was awarded the commission for the eight-foot bronze at the State Capitol, Honolulu by the Hawaiian Legislature. It commemorates the valiant struggle by the Hawaiian kingdom's last monarch to maintain her country's independence. Over four years of work involving research and sculptural studies was needed to create the final version, dedicated in 1982. *—MP*

PLATE 43
Study for the Spirit of Lili'oukalani

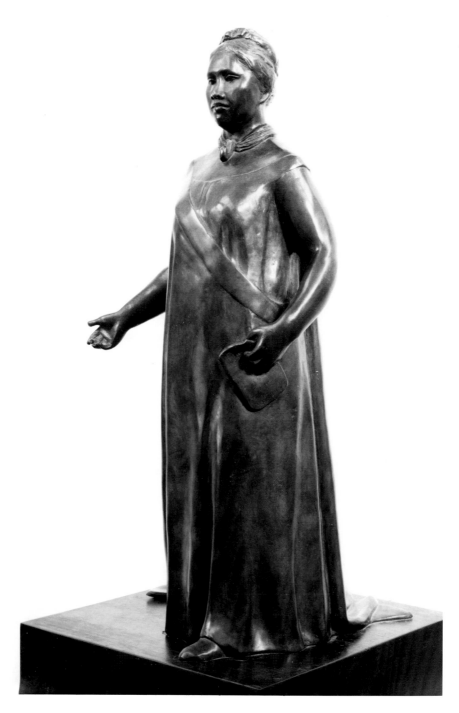

PLATE 44
Competition Maquette,
The Spirit of Lili'oukalani

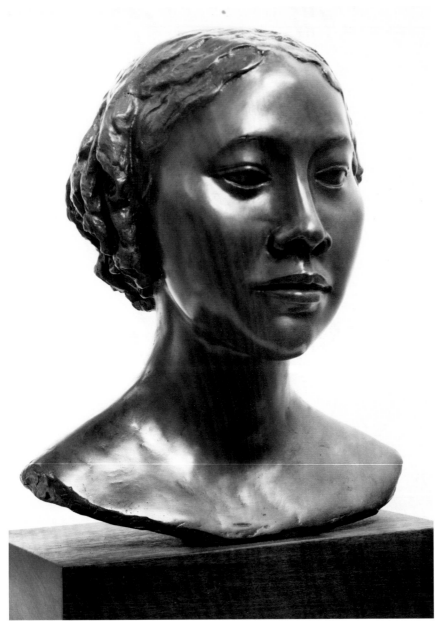

PLATE 45
Lili'uokalani as a Child

In 1993 Hawaii observed the Centennial of the overthrow of the Constitutional Monarchy of the Hawaiian Islands by U. S. forces. The last monarch, Queen Lili'uokalani's spirited defense of Hawaii's independence resulted in her humiliating trial and imprisonment. Undaunted, Lili'uokalani traveled five times to Washington to plead her country's cause, convinced the Congress would reverse such an obvious injustice. Disappointed, she retired to live a long life as a beloved private citizen.

In 1982 an eight-foot high bronze sculpture by Marianna Pineda, titled, "The Spirit of Lili'uokalani," was unveiled at the State Capitol in Honolulu. Commissioned by the State Legislature through an international competition, the statue has become a focus of activities dedicated to Hawaiian rights. The Queen symbolizes renewed Hawaiian pride in land, language, history and culture.

This group of studies for the monument is based on a large collection of photographs that span Lili'uokalani's lifetime, from schoolgirl to proud sovereign to venerable matriarch. Taken together the bronzes, terracottas and drawings constitute a kind of narrative portrait, or informal sculptural biography—presented "as a way of including the spectator in the search for the outward aspects of a noble spirit."

From exhibition pamphlet, "Marianna Pineda: Search for the Queen", The Judi Rotenberg Gallery, Boston, MA, 1993.

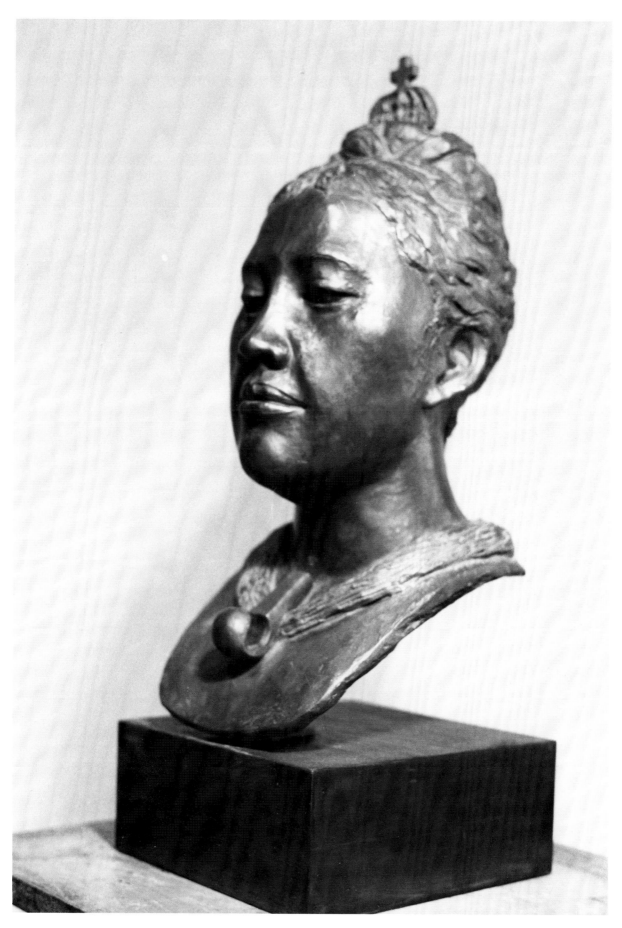

PLATE 46
Lili'uokalani Regent

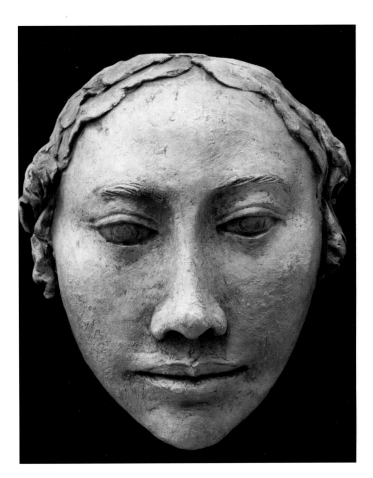

PLATE 47
Mask of Lili'uokalani as a Child

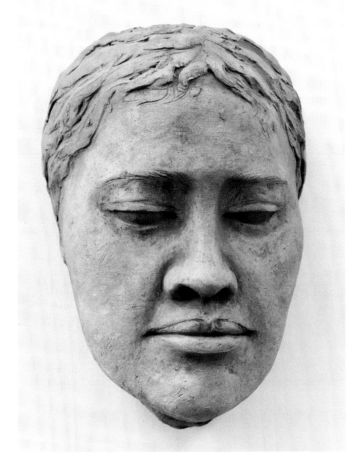

PLATE 48
Mask of Lili'uokalani, Regent

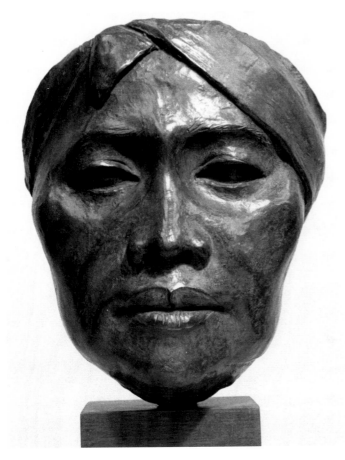

PLATE 49
Mask of the Mature Lili'uokalani

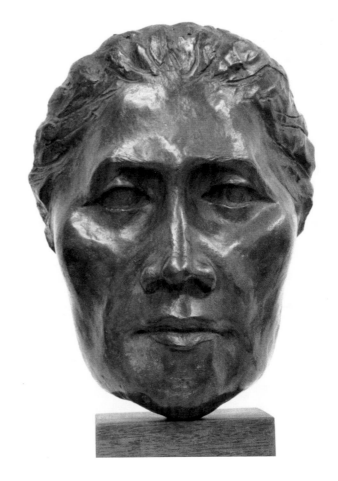

PLATE 50
Mask of the Aged Lili'uokalani

PLATE 51

Queen on a Galloping Horse

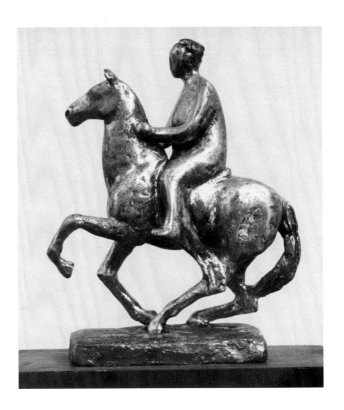

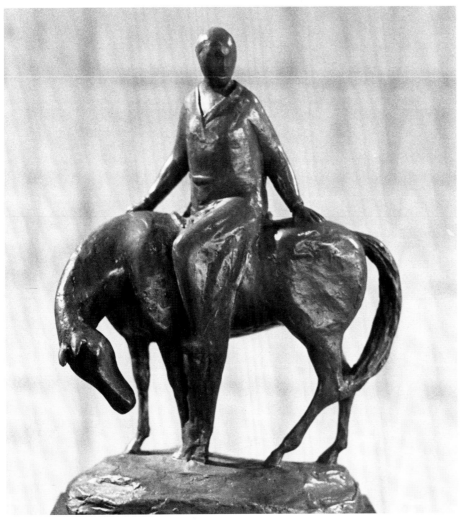

PLATE 52

Looking Down From the Pali

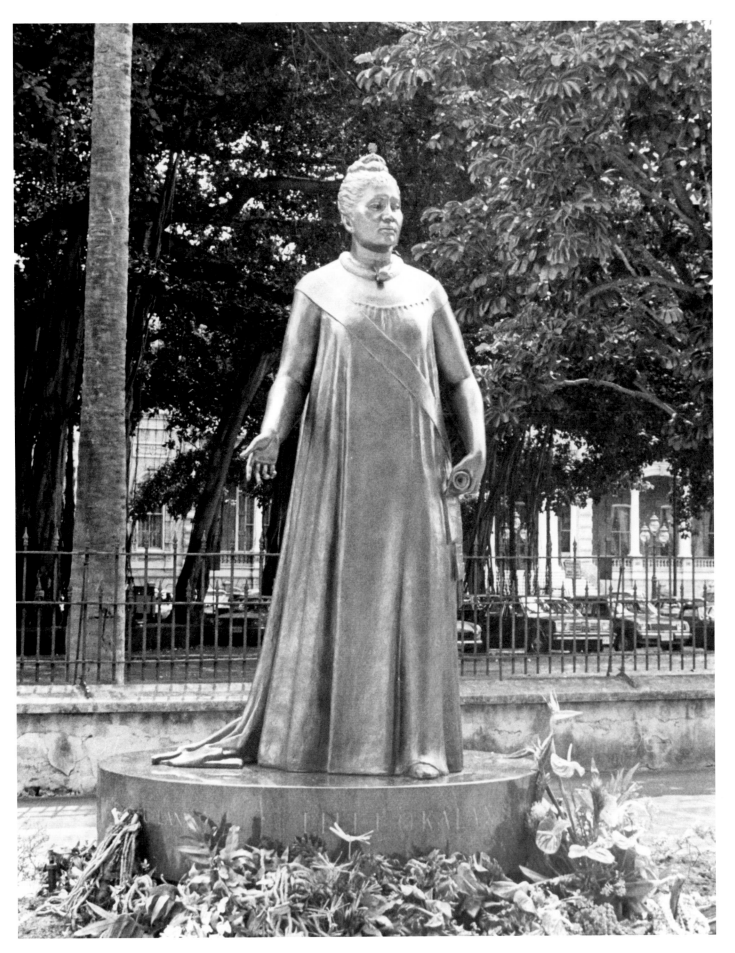

PLATE 53
The Spirit of Lili'uokalani

THE EVE CELEBRANT SERIES

The Eve Celebrant series of sculptures explores the pre-biblical concept of a powerful, creative and generous female deity, celebrated by Eve, who proudly offers the pomegranate, symbol of knowledge and fruitfulness, as sacrament. This is the ancient, suppressed symbol of Eve as creatrix and bearer of knowledge (a counter force to the later tradition of Eve, the source of all human misery). She is also the future Eve, partner and equal of the masculine principal. She is maiden, matron, crone: she is all races and all ages.

I feel somewhat like a choreographer as I create a sense of movement in and between my figures. And they will never tire. —MP

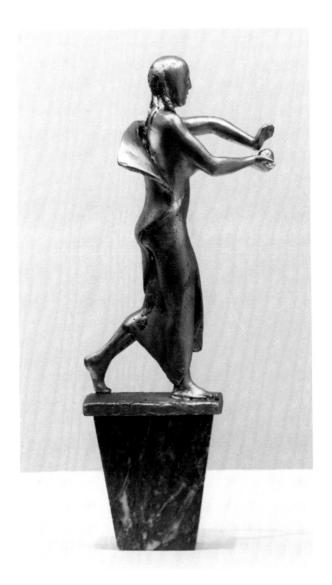

PLATE 54
Maquette for Eve Celebrant

Ritual Memory: strength

Body

in conversation

with night dream water air

memory of nights of love dancer

in prayer in procedure remembering

the music of the ancestors listener

respectful of what precedes us follows us

protects us

— John Tagliabue

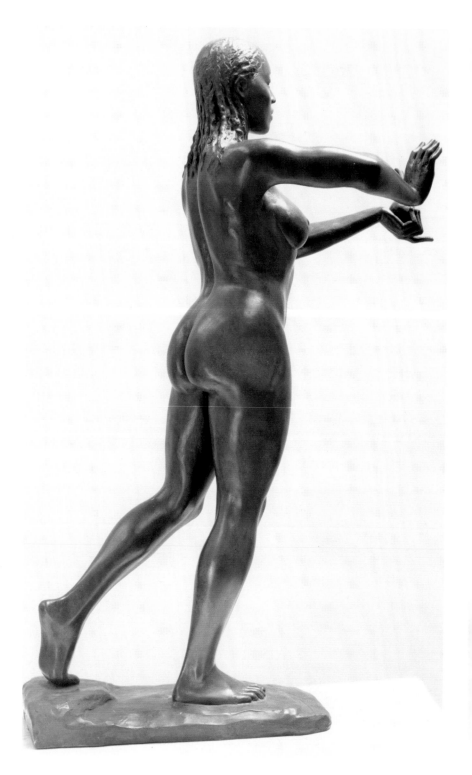

PLATE 55
Life Study

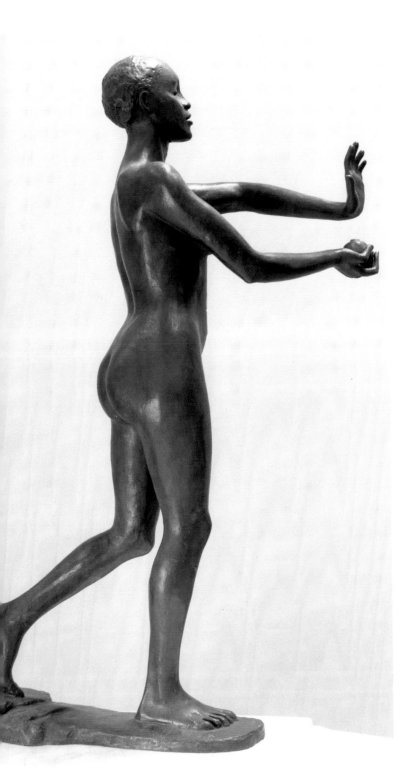

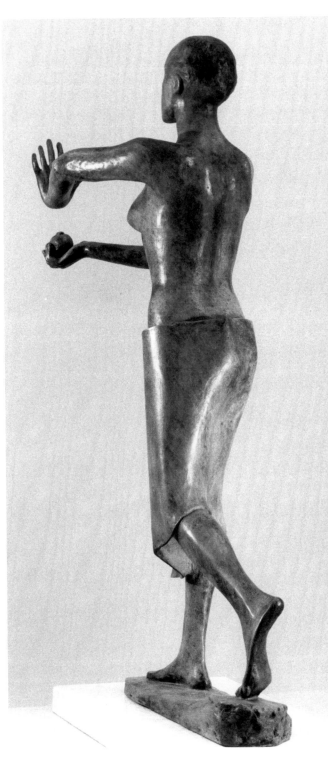

PLATE 56
Serengeti Plain I

PLATE 57
Serengeti Plain II

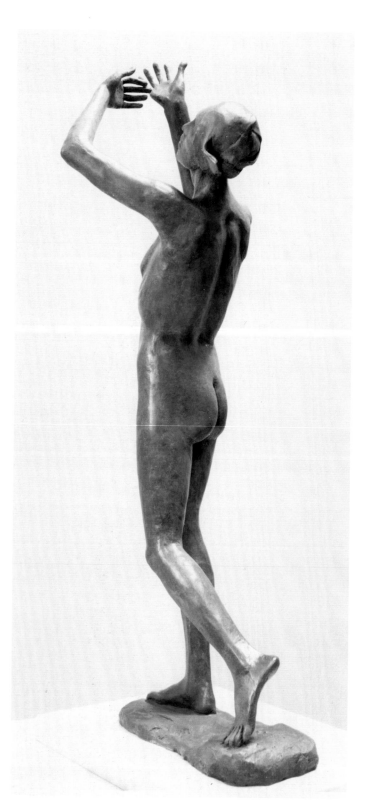

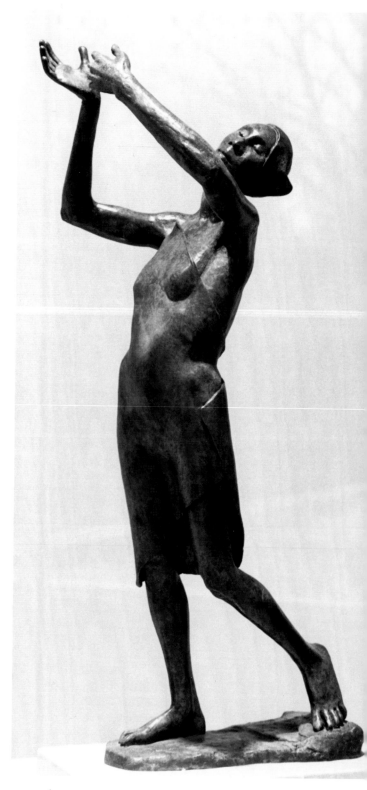

PLATE 58
Dance of the Matriarch I

PLATE 59
Dance of the Matriarch II

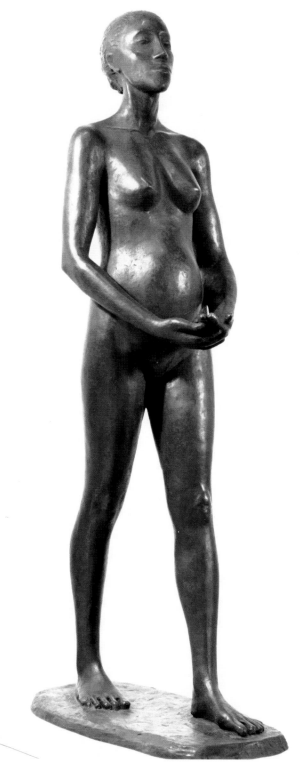

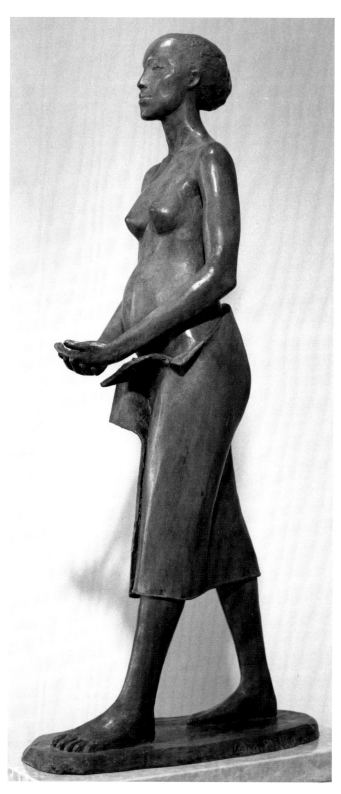

PLATE 60
Nile Valley I

PLATE 61
Nile Valley II

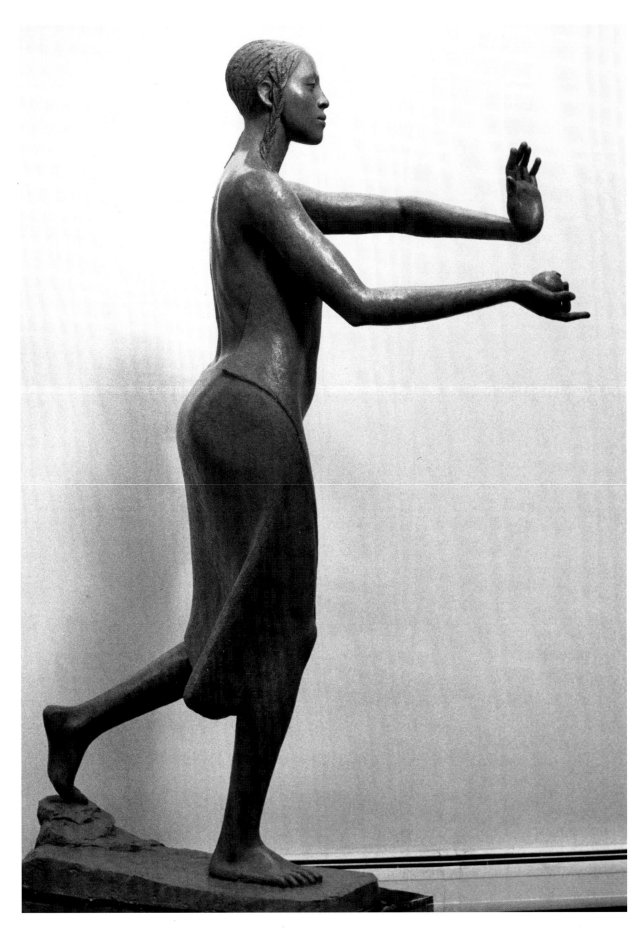

PLATE 62
Eve Celebrant

PLATE 63
Study for Defendant

DEFENDANT

*Defendant is based on a newspaper
account and photograph of an unfortu-
nate and abandoned woman on trial
for the inadvertent drowning of her
two infants.* —MP

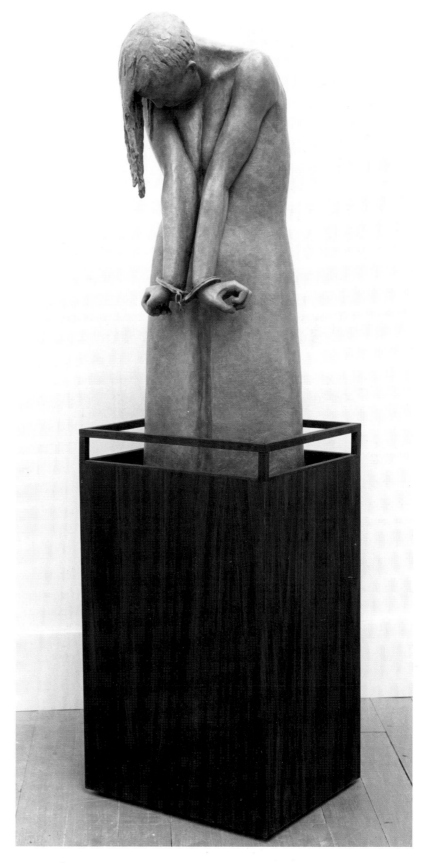

PLATE 64
Defendant

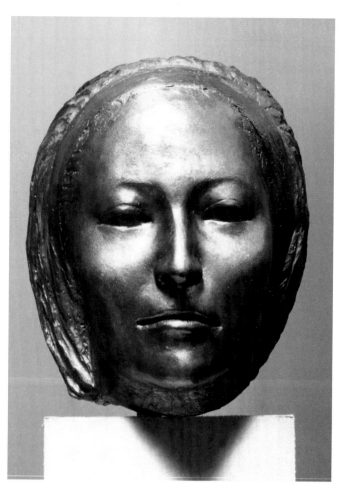

PLATE 65
Martha Swetzoff

PLATE 66
Martin Sumers

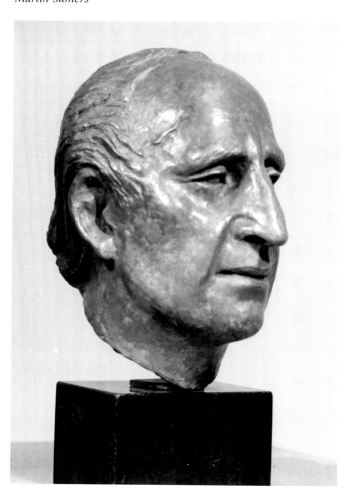

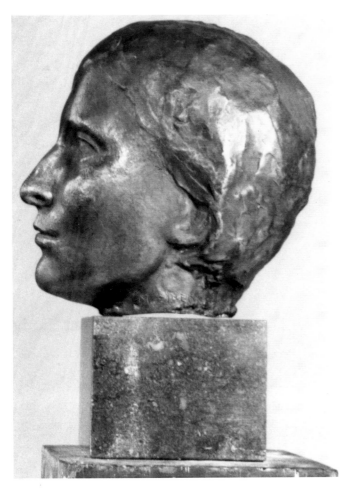

PLATE 67
Portrait of Gertrude S.

PLATE 68
Harold Tovish

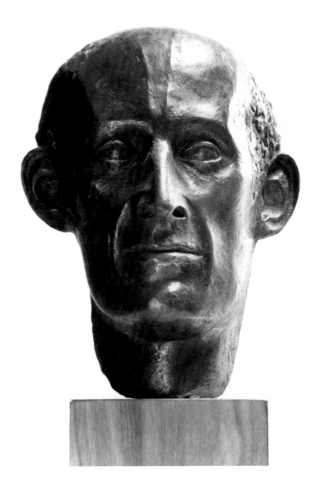

LIST OF WORKS ILLUSTRATED

Edition of 3, 28×7×7" (71×18×18 cm)
Private Collections.

PLATE 36

*Study for Aspects of the Oracle:
Exhausted* 1963
Bronze with steel tripod, Edition of 3,
22×4×3" (56×10×7.5 cm)
Private Collections.

PLATE 37

Aspect of the Oracle: Rapturous 1985
Original Fiberglass, Fiber and Steel (for
Bronze, Edition of 5)
82×48×40" (208×122×102 cm)

PLATE 38

Aspect of the Oracle: Portentous 1967
Unique Bronze, 71" (180 cm)
Radcliffe College, Cambridge, MA.
Gift of the Artist's Family.

PLATE 39

Judith 1982
Bronze, Edition of 3, 24.75×12.5×6.75"
(63×32×17 cm) Private Collection.

PLATE 40

Resting in Half Lotus 1977
Bronze, Edition of 3,
15×24×24" (38×61×61 cm)
Private Collections.

PLATE 41

Twirling (detail) 1975
Bronze, 2×2' (61×61 cm)
Sumner Street Housing for the Elderly, East
Boston, MA.

PLATE 42

Twirling 1975
Bronze, 2×2' (61×61 cm)
Sumner Street Housing for the Elderly, East
Boston, MA.

PLATE 43

Study for The Spirit of Lili'uokalani 1981
Brown Wash on grey paper, 9×8" sight
(23 × 20 cm)

PLATE 44

*Competition Maquette, The Spirit of
Lili'uokalani* 1978
Bronze, Edition of 10,
24×11×10.5" (61×28×26.5 cm)
Private Collections.

PLATE 45

Lili'uokalani as a Child 1980
Bronze, Edition of 10, 10×10.5×8"
(25×26.5×20 cm) Private Collections.

PLATE 46

Lili'uokalani Regent 1980
Bronze, Edition of 10, 18.5×8.5×8"
(47×21.5×20 cm)
Perseus Collection, Honolulu, HI
and Private Collections.

PLATE 47

Mask of Lili'uokalani as a Child 1980
Unique Terracotta, 7.5" (19 cm)

PLATE 48

Mask of Lili'uokalani, Regent 1980
Unique Terracotta, 10×6.25×3"
(25.5×16×7.5 cm)

PLATE 49

Mask of the Mature Lili'uokalani 1980
Bronze, 8×6×4.5"
(20×15×11.5 cm)

PLATE 50

Mask of the Aged Lili'uokalani 1980
Bronze, Edition of 10, 8.5×6×4.5"
(22×15×11 cm)

PLATE 51

Queen on a Galloping Horse 1981
Bronze, Edition of 15, 7×5.5×2" (18×14×5
cm) Private Collections.

PLATE 52

Looking Down From the Pali 1981
Bronze, Edition of 10, 13×9.5×5.5"
(33×24×14 cm) Private Collection.

PLATE 53

The Spirit of Lili'uokalani 1981
Unique Bronze, 96×32×52" (244×81×132
cm) State Capitol, Honolulu, HI.
The Hawaiian State Foundation on Culture
and the Arts.

PLATE 54

Maquette for Eve Celebrant 1987
Bronze, Edition of l5, 8.25×5.25×2.25"
(21×13×5.5 cm)
Private Collections.

PLATE 55

Life Study 1988
Bronze, Edition of 5, 27.75×16×16"
(70×41×41 cm)

PLATE 56

Serengeti Plain I 1989
Bronze, Edition of 5, 27×8.25×17.5"
(69×21×44.5 cm)

PLATE 57

Serengeti Plain II 1989
Bronze, Edition of 5, 27×8.25×17.5"
(69×21×44.5 cm)

PLATE 58

Dance of the Matriarch I 1989
Bronze, Edition of 5, 30×13×9.75"
(76×33×25 cm) Dr. Ann Appelbaum,
Watch Hill, RI.

PLATE 59

Dance of the Matriarch II 1990
Bronze, Edition of 5, 27.5×10×14"
(70×25×35.5 cm) Walter Brinkjans,
Ensdetton, Germany.

PLATE 60

Nile Valley I 1991
Bronze, Edition of 5, 27.5×8.75×13"
(70×22×33 cm)

PLATE 61

Nile Valley II 1991
Bronze, Edition of 5, 28.5×6.5×13"
(72×16.5×33 cm)

PLATE 62

Eve Celebrant 1991
Fiberglass for Bronze, Edition of 5,
78×38×18" (198×97×45 cm)

PLATE 63

Studies for Defendant 1986
Lithocrayon, 13.5×10.5" & 13.5×10.5"
(34×26.5 cm & 34×26.5 cm)

PLATE 64

Defendant 1986
Bronze and Wood, Edition of 5, 75×22×18"
(190×56×45 cm)

PLATE 65

Martha Swetzoff 1995
Plaster for Bronze, Edition of 3,
10×8×9.75" (25×20×25 cm)
Sarah Weeks Peabody, Brookline, MA.

PLATE 66

Martin Sumers 1994
Bronze, Edition of 3, 11×7.75×9.5"
(28×19.5×24 cm)

PLATE 67

Gertrude S. 1970
Bronze, 9.5×7×8" (24×18×20 cm)
Collection of the National Academy of
Design, NYC.

PLATE 68

Harold Tovish 1982
Bronze, 11×9×5.75" (28×23×14.5 cm)

A note on the measurements:
*Base included in measurement only when
integral to the sculpture. Height precedes
width precedes depth. If only one measure-
ment is given, it is the longest measurement
of the sculpture.*

A note on the collections:
*All works listed without a collection, public
or private, are leant by the artist and her
family. These works are made available
courtesy of the Judi Rotenberg Gallery,
Boston, MA.*

AUTOBIOGRAPHICAL NOTES

I WAS BORN IN 1925 IN EVANSTON, Illinois to Marianna (Dickinson) and George Packard, the only daughter of three children.

In my early years I was treated to the rich cultural life of Chicago: museums, ballet, modern dance and music. I studied dance for four summers at the M. K. Pearse Camp in Wisconsin. Our family also made tours of the Mediterranean and Paris and a globe-circling voyage south of the Equator. The effect on an art-hungry youngster of seeing Karnak, Athens, and The Louvre in addition to the splendor of Bali and other exotic cultures cannot be overestimated. Also books such as Malvina Hoffman's *Inside and Out,* and the experience of three World's Fairs that featured large works by women—including Chicago in 1933, San Francisco in 1944 and New York City in 1964—played a significant role in my development.

In 1938 my family moved to Southern California, where I attended weekly classes at the Otis Art Institute and the Chinourd School of Art. The summer of 1942 was spent at the Cranbrook Art Academy under the benign presence of Carl Milles and his figurative fountains. That fall I entered Bennington College, hoping to specialize in sculpture immediately, but my plan was not approved. However, because of the wartime fuel rationing, Bennington instituted a four month "Winter Period", during which time students were required to pursue individual projects. I worked part-time at the Museum of Modern Art and had several months of study in the art department of Columbia University, where I met my future husband, the sculptor

Harold Tovish. I then returned to the West Coast and enrolled in the art department at the University of California at Berkeley, where I studied sculpture from 1943 to 1945 under Raymond Pucinelli. I worked several days a week in his studio as an assistant as well. I started using Pineda as a professional surname to avoid confusion with a distinguished California artist.

In 1945 I returned to Columbia to continue study under Oronzio Malderelli. World War II ended and Harold Tovish returned from the Army. We were married in 1946. Our daughter, Margo, was born in 1947, followed by the birth of our son, Aaron, in 1949.

In 1949 we moved to Paris for nineteen months of intensive work, starting with four months at the Ossip Zadkine School of Sculpture and continuing in our studio. I completed my first bronze sculptures.

A job offer brought us to the lively cultural climate of St. Paul/Minneapolis in 1951 for three years. In 1954 we moved to Florence, Italy, found studios, friends and a small city where everyday one could bump into a masterpiece in a piazza where it had been a vital presence for centuries. The continuing traditions of skilled craftsmen made the transition from clay to plaster to bronze a joy for a sculptor.

In 1957 we were offered teaching jobs in the Boston area and, after a summer at the Skowhegan School of Art in Maine, settled in Brookline, Massachusetts. We were warmly welcomed, not only by the artists we had met at Skowhegan, but also by the circle of friends of our remarkable art

dealer, Hyman Swetzoff. Our second daughter, Nina, was born in 1958. I had turned down the teaching job to spend more time with our children and work in my studio at home.

In 1962, a two year fellowship at the Radcliffe Institute for Independent Study (now the Bunting Institute) conferred status, some helpful money and a wonderful new group of friends. The seventies were marked by public commissions, completed and commenced, the most notable being *The Spirit of Lili'uokalani* for the state of Hawai'i. I worked over four years in my vast new Boston studio, first on sculptural studies and then directly in clay on the eight-foot figure. The bronze was dedicated in Honolulu in 1982.

I taught for a period of five years, beginning in 1972 at the Newton College of the Sacred Heart, which was later absorbed by Boston College. In 1974 I was appointed Visiting Associate Professor at Boston University for four years. I returned to Boston University in 1982 for two years, and taught there again in 1989–1990.

In 1985, work in my new Cambridge studio was returning to a more personal vein. I enlarged *Rapturous,* from *The Oracle* series, and began the new *Eve Celebrant* series.

In 1995 I embarked on a two-year project developing a video tape, called *Search for the Queen,* about the creation of the monument—interwoven with a brief history of the last reigning monarch of Hawai'i.

I am grateful for parents, a husband, family and fellow artists who have supported and enriched a lifetime of sculpture-making.

—M.P.

PUBLIC COLLECTIONS

Addison Gallery of American Art, Andover, MA

Boston Public Library, Boston, MA

Bowdoin College, Brunswick, ME

City of Boston, MA

Hood Museum of Art, Dartmouth College, Hanover, NH

Fogg Art Museum, Harvard University, Cambridge, MA

Mt. Holyoke College, South Hadley, MA

Munson-Williams-Proctor Institute, Utica, NY

Muscarelle Museum of Art, Williamsburg, PA

Museum of Fine Arts, Boston, MA

National Academy of Design, NYC

Queen Lili'uokalani Children's Center, Honolulu, HI

Radcliffe College, Cambridge, MA

State of Hawaii

University of Massachusetts, Amherst, MA

Wadsworth Atheneum, Hartford, CT

Walker Art Center, Minneapolis, MN

Williams College, Lawrence Art Museum, Williamstown, MA

PUBLIC COMMISSIONS

Jan Veen Memorial Medallion, c. 1969, bronze. At the library of the Boston Conservatory of Music, Boston, MA.

Leavetaking, 1975, bronze. A relief given by Class of 1975, Newton College. Sited in the Chapel of the Newton Campus, Boston College, Boston, MA.

Twirling, 1975, bronze. A two-figure group created for the Sumner Street Housing for the Elderly in East Boston, MA. Sponsored by the Boston Redevelopment Authority.

The Spirit of Lili'uokalani, 1982, bronze. An eight-foot portrait of the last reigning monarch of Hawai'i, Pineda's design was chosen in 1977. It was installed at the State Capitol Building, Honolulu, HI in 1982.

Celebrant, 1988, bronze. An 8" figure for the "Jack Lemmon Award" given by the Wang Center for the Performing Arts, Boston, MA. Jack Lemmon, Christopher Reeve, Yo-Yo Ma and Lee Remick received this award.

HONORS/GRANTS/ AWARDS

1996

National Sculpture Society, Herbert Adams Medal.

National Women's Caucus for Art, Lifetime Achievement Award.

1995

Thanks Be to Grandmother Winnefred Foundation, funding to finish "Search for the Queen" video.

Robert Florsheim Art Fund Award, funding to produce this catalogue.

New England Foundation for the Humanities Award, funding for public presentation of "Search for the Queen" video with a panel of experts.

1993

National Academy of Design, NYC, Artists Award for Best Sculpture.

1991

National Sculpture Society, NYC, Talix Foundry Award.

1988

Advanced to Academician of the American Academy of Design, NYC.

National Academy of Design, NYC, "Annual Exhibition," Artists Award.

Elected Fellow of the National Sculpture Society.

National Sculpture Society, Gold Medal, NYC, Annual Exhibition.

1987

National Academy of Design, NYC, "Annual Exhibition," Gold Medal.

1986

National Sculpture Society, NYC, Lampston Prize.

National Academy of Design, NYC, "Annual Exhibition," Artists Award.

1962

Bunting Institute, Radcliffe College, Cambridge, MA, Fellow (renewed in 1963).

1960

Boston Arts Festival, MA, Grand Prize.

1958

Institute of Contemporary Art, Boston, MA, Margaret Brown Memorial Prize.

Providence Art Club, Providence, RI, Kane Memorial Award: Sculpture.

1957

Chicago Art Institute, Chicago, IL, "64th American Exhibition," Mather Prize, Sculpture.

Portland Museum of Art, Portland, ME, First Prize: Sculpture

Boston Arts Festival, Boston, MA, Third Prize: Sculpture.

1955

San Francisco Art Association, "74th Annual Painting and Sculpture Exhibition," First Prize: Sculpture.

1954

Minnesota State Fair, St. Paul, MN, Best of Show Award.

1951

Walker Art Center, Minneapolis, MN, Biennial Regional Show Purchase Award: Sculpture.

1947

Albright Art Gallery, Buffalo, NY, "14th Annual Western New York Exhibition," Reeb Award for Drawing.

1944

Oakland Civic Museum, Oakland, CA, Second Prize for Sculpture.

SOLO EXHIBITIONS

1996

Judi Rotenberg Gallery, Boston, MA, "Women in Art"

Dimock Gallery, George Washington University, Washington, D.C.

1994

Judi Rotenberg Gallery, Boston, MA, "Drawings, Dancers: Motion/Repose"

1993

The Wiggin Gallery, Boston Public Library, Boston, MA, "A Retrospective of Drawing"

Judi Rotenberg Gallery, Boston, MA, "Search for the Queen"

1992

Andrews Gallery, College of William & Mary, Williamsburg, VA, "Four Decades of Drawing"

1990

Judi Rotenberg Gallery, Boston, MA, "The EVE CELEBRANT Series"

1984

Pine Manor College, Chestnut Hill, MA, "Sculpture and Drawings"

1982

Contemporary Arts Center, Honolulu, HI, "Search for the Queen"

Hulihee Palace, Kona, HI

Lyman Museum, Hilo, HI

1974

Bumpus Gallery, Duxbury Free Library, Duxbury, MA

1972

Kenny-Cottle Library, Newton College, Newton, MA, "Twenty Years of Sculpture"

Alpha Gallery, Boston, MA

1970

Honolulu Academy of Art, Honolulu, HI

1964

Swetzoff Gallery, Boston, MA (also 1956 and 1953)

1963

Premier Gallery, Minneapolis, MN

1954

DeCordova and Dana Museum, Lincoln, MA

Currier Gallery, Manchester, NH

1952

Walker Art Center, Minneapolis, MN

1951

Slaughter Gallery, San Francisco, CA

SELECTED GROUP EXHIBITIONS

1996

Rose Art Museum, Brandeis University, Waltham, MA, "Women's Caucus for Art 1996 Honor Awards"

1995

Danforth Museum, Framingham, MA, "Honored Artists: Still Working"

Newhouse Center for Contemporary Art, Staten Island, NY, "In Three Dimensions: Women Sculptors of the 1990s"

The Wiggin Gallery, Boston Public Library, Boston, MA, "The Art of the Poster in Boston"

Sculptors Guild, NYC, "Within 10"×10""

National Academy of Design Annual, NYC (annually since 1991)

1994

Art Gallery, Kingsborough Community College, CUNY, Brooklyn, NY, "Contemporary Figurative Sculpture"

The University of Hawaii Art Gallery, Honolulu, HI, "The 5th Annual Shoebox Sculpture Exhibition" (traveling through 1996)

1993

Sculptors Guild, NYC, and Municipal Gallery, Kyoto, Japan, "Soho/Kyoto"

National Sculpture Society, NYC, "Americas Towers Inaugural Exhibition"

1991

Walsh Art Gallery, Fairfield University, Fairfield, CT, "National Sculpture"

Judi Rotenberg Gallery, Boston, MA, "The Expressive Line"

Wingspread Gallery, East Harbour, MA

1990

The Contemporary Museum, Honolulu, HI, "Silver Anniversary of the State Foundation on Culture and the Arts Collection"

Luis Ross Gallery, NYC, "Sculptors Draw the Figure"

Sculptors Guild Gallery, NYC, "Expressionism in Sculpture"

School of the Museum of Fine Arts, Boston, MA, "Faculty Exhibition"

1989

National Sculpture Society, NYC, "Soho Exhibition"

Page Street Gallery, San Francisco, CA and Shidoni Galleries, Santa Fe, NM, "Sculptors Guild Bi-Coastal Exhibition"

Washington Art Association, Washington Depot, CT, "Two Sculptors"

Bumpus Gallery, Duxbury Free Library, Duxbury, MA, "Sculpture Projects: Personal and Public"

Judi Rotenberg Gallery, Boston, MA, "The Art of the 90s"

Judi Rotenberg Gallery, Boston, MA, "Sculpture, Sculpture, Sculpture"

Mount Holyoke College Art Museum, South Hadley, MA, "Through Women's Eyes"

1988

National Academy of Design, NYC, "Annual Exhibition"

National Sculpture Society, NYC, "Annual Exhibition"

The Sculptors Guild, Lever House, NYC, "50th Anniversary Exhibition"

The Wiggin Gallery, Boston Public Library, Boston, MA, "Drawing in Boston"

A.I.R. Gallery, NYC, "Boston Invitational"

1987

National Academy of Design, NYC, "Annual Exhibition"

Alchemie Gallery, Boston, MA, "Editor's Choice: Nine Northeastern Women Sculptors"

The Wiggin Gallery, Boston Public Library, Boston, MA, "Works on Paper by Women"

Schulman Sculpture Park, White Plains, NY, "Sculptors Guild Installation" (through 1988)

A.B. Closson Jr. Gallery, Cincinnati, OH, "Sculpture by Women"

Port of History Museum, Philadelphia, PA, "National Sculpture Society, Survey of Figurative Sculpture"

DeCordova Museum, Lincoln, MA, "Drawing from Boston"

Brockton Art Center, Brockton, MA, "Triennial Exhibition"

1986

Boston Visual Artists Union, Boston, MA, "15th Anniversary Invitational Show"

Federal Reserve Gallery, Boston, MA, " Collected Visions: Women Artists of the Bunting Institute, 25th Anniversary Exhibition"

Boston University Art Gallery, Boston, MA, "The Human Presence in Sculpture"

Provincetown Art Association and Museum Annual, Provincetown, MA

1985

Boston Arts Festival, Boston, MA, "Invitational Show"

Newton Arts Center, Newton, MA, "Sculpture: Public Commissions/Private Work"

1984

Newton Arts Center, Newton, MA, "The Full Circle"

Fitchburg Museum of Art, Fitchburg, MA, "Aspects of the Figure"

1983

Bethune Gallery, SUNY, Buffalo, NY, "Portrait Sculpture—Contemporary Points of View"

Martin Sumers Graphics Gallery, NYC, "Small Sculpture"

National Academy of Design, NYC, "158th Annual Exhibition"

1982

Boston University Art Gallery, Boston, MA, "Boston Portraits"

Helen Shlein Gallery, Boston, MA, "Small Bronzes"

Van Buren, Brazelton, Cutting Gallery, Cambridge, MA, "Fears and Affirmations"

1981

Knott Art Gallery, Bradford College, Bradford, MA, "Works on Paper"

1980

Simmons College, Boston, MA, "Women Artists"

Boston Visual Artists Union, Boston, MA, "The Male Figure"

1979

Hirshberg Gallery, Boston, MA, "Bennington College Art"

1978

Brockton Art Museum, Brockton, MA, "Artists in Boston"

1977

The Woman's Building, Los Angeles, CA, "Contemporary Issues—Works by Women" (traveling)

1975
DeCordova Museum, Lincoln, MA, "New England Women"

The Goethe Institute, Boston, MA, "Boston Visual Artists Invitational"

1974
Pennsylvania State University, University Park, PA, "Living American Artists and the Figure"

Boston Visual Artists Union, Boston, MA, "Open Exhibition at the Cyclorama" (also 1973)

Radcliffe College, Cambridge, MA, "Inaugural Exhibition of the Radcliffe [Bunting] Institute"

Nashua Center for Art and Science, Nashua, NH, "WEB Invitational"

1972
DeCordova Museum, Lincoln, MA, "Outdoor Sculpture 1972"

1971
Design Center of Iowa State University, Ames, IA, "American Drawing"

1967
Radcliffe College, Hilles Library, Cambridge, MA, "Artists of the Radcliffe Institute"

1966
Birmingham Museum of Art, Birmingham, AL, "Religion and Art"

1965
Northeastern University, Boston, MA, "New England Art Today" (also 1963)

Jewett Art Center, Wellesley College, Wellesley, MA

1964
DeCordova Museum, Lincoln, MA, "New England in Five Parts: Sculpture"

Pavilion of Fine Arts, New York World's Fair, NYC

1963
DeCordova Museum, Lincoln, MA, "New England in Five Parts: Drawing"

University of Massachusetts, Amherst, MA "Acquisitions—Drawing"

Bundy Art Gallery, Waitsfield VT, "First Sculpture Exhibition"

Boston Arts Festival Boston, MA (also 1962, 1958, 1957)

Boston University Art Gallery, Boston, MA "Friends of Art" (also 1961, 1963)

1962
Mount Holyoke College Art Museum, South Hadley, MA, "Women Artists in the U.S. Today"

1961
Institute of Contemporary Art, Boston, MA, "View" (traveling)

University of Colorado, Denver, CO

National Institute of Arts and Letters, NYC

Art Institute of Chicago, Chicago, IL, "64th American Exhibition of Painting and Sculpture"

Dallas Museum of Fine Arts, Dallas, TX, "Young Collector's Show"

Sculptors Guild, NYC (annually after)

1960
Museum of Fine Arts, Boston, MA, "Recent Sculpture" (traveling)

Swain School of Design, Crapo Gallery, New Bedford, MA

1959
Whitney Museum of American Art, NYC (also 1957, 1955, 1954, 1953)

Museum of Modern Art, NYC, "Recent Sculpture" (traveling)

Institute of Contemporary Art, Boston, MA, "Selection 1"

Addison Gallery of American Art, Andover, MA, "The American Line: 100 Years of American Drawing"

1958
Institute of Contemporary Art, Boston, MA

Carnegie Institution, Pittsburgh, PA, "Pittsburgh International"

Providence Art Club, Providence, RI

1957
Chicago Art Institute, Chicago, IL, "64th American Exhibition"

Museum of the Legion of Honor, San Francisco, CA, "United Nations Exhibition"

Silvermine Guild of Artists, New Canaan, CT, "Annual Exhibition"

Portland Museum of Art, Portland, ME

University of Illinois, Urbana, IL

1956
Boston Society of Independent Artists, Boston, MA

Denver Art Museum, Denver, CO, "Summer Exhibition"

1955
San Francisco Museum of Art, San Francisco, CA "San Francisco Art Association 74th Annual Painting and Sculpture Exhibition"

Chicago Art Institute, Chicago, IL, "62nd American Exhibition"

1954
Minnesota State Fair, St. Paul, MN

Minneapolis Art Institute, Minneapolis, MN, "Local Artists Show"

Ohio State University, Columbus, OH "Contemporary Sculptors' Drawings"

1953
University of Nebraska, Lincoln, NE

Colorado Springs Art Center, Colorado Springs, CO, "Duo Exhibition"

1952
Sculptors Guild, NYC

1951
Metropolitan Museum, NYC, "American Sculpture"

Walker Art Center, Minneapolis, MN, "Biennial Regional Show"

1950
Gallerie 8, Paris, France, "American Painters and Sculptors"

1947
Albright Art Gallery, Buffalo, NY, "14th Annual Western New York Exhibition"

Brooklyn Museum, NYC, "31st Sculpture Annual"

1946
Village Art Center, NYC

1944
Oakland Civic Museum, Oakland, CA

SELECTED PUBLICATIONS & REVIEWS

1996
Hills, Patricia. "Marianna Pineda." *Women's Caucus for Art 1996: Honor Awards.* Waltham, MA: Rose Art Museum of Brandeis University, 1996.

Mehal, Chris and Marianna Pineda. *Search for the Queen: Creating the Spirit of Lili'uokalani for the People of Hawai'i.* 1996 (video).

Stapen, Nancy. "Multicultural Thrust Blurs Women's Work." *Boston Globe* (23 February 1996): 52.

1994
Preble, Duane and Sarah Preble. *Artforms: An Introduction to the Visual Arts.* 5th ed. New York: Harper Collins Publishers, 1994.

Who's Who in America: 1995. 49th ed. Vol. 2. New Providence, NJ: Reed Reference Publishing, 1994.

1993
"Marianna Pineda Works: 1952-1990." *The New Renaissance* 9, no. 1 (Fall 1993): 10, 136-144.

Seiden, Sloan. "The Pensive Form: Musing, Pondering, Dreaming." *Sculpture Review* 42, no.2 (1993): 12-17.

Sherman, Mary. "Library Exhibit Offers Works by Two Women." *Boston Herald* (19 February 1993): S18.

1992

Dickerman, Sara. "Radcliffe Bronze: Metaphor for Women." *Arts Spectrum* [Radcliffe College] (March 1992): 5.

Pineda, Marianna. "Rodin's Portrayal of Women." *Sculpture Review* 41, no. 4 (1992): 20-26.

1990

Carlock, Marty. "Marianna Pineda: The Eve Celebrant Series." *Art New England* 12, no. 2 (February 1991): 42.

Rubinstein, Charlotte S. *American Women Sculptors: A History of Women Working in Three Dimensions.* Boston: G.K. Hall & Co., 1990.

Stapen, Nancy. "Pineda Sculpts Classical Figurative Forms." *Boston Globe* (22 November 1990): A60

1987

Creamer, Beverly. "A Proper Setting for the Queen." *The Honolulu Advertiser* (14 October 1987): C-1, C-3.

Faxon, Alicia and Sylvia Moore, eds. *Pilgrims and Pioneers: New England Women in the Arts.* New York: Midmarch Arts Press, 1987.

Stapen, Nancy. "An Eclectic Collection of Sensuality." *The Boston Herald* (28 June 1987): S4.

1986

Frick, Thomas. "BVAU 15th Annual Invitational." *Art New England* 7, no. 3 (March 1986): 13.

Nickerson, Ruth. "A Vanguard of American Women Sculptors." *Sculpture Review* 35 (Winter 1986-87): 16-24+.

Stapen, Nancy. "Classical Figure Still Alive." *The Boston Herald* (11 December 1986): 45.

Taylor, Robert. "Visual Artists Union Marks 15th Anniversary in Style." *The Boston Globe* (26 January 1986): 45.

Tovish, Nina. "Community, Continuity, Activity and Change: Celebrating Fifteen Years of Artists' Unity." *BVAU [Boston Visual Artists Union] News* 14, no. 5 (January 1986): 1, 4.

Watson-Jones, Virginia. *Contemporary American Women Sculptors.* Phoenix, AZ: Oryx Press, 1986.

1985

Temin, Christine. "4 Boston Sculptors Share Powerful Style." *The Boston Globe* (23 May 1985): 91.

1984

Pineda, Marianna. "Sculpture is an Act of Faith." *Radcliffe Quarterly* 70, no. 2 (June 1984): 29-30.

Opitz, Glenn B., ed. *Dictionary of American Sculptors: "18th Century to Present".* Poughkeepsie, NY: Apollo Books, 1984.

Taylor, Robert. "Exhibits: Pineda's Vision." *The Boston Globe Calendar* 9, no. 17 (1 March 1984): 25.

1982

Hughes, Maxine. "Sculptural Biography of Queen Lili'uokalani." *Hawaii Tribune-Herald* (17 October 1982): 18.

Ichida, Karl. "Marianna Pineda's Search for the Queen." *Cultural Climate: The Monthly Bulletin of the Arts Council of Hawaii* (April 1982): n.p.; from Marianna Pineda scrapbook.

Krauss, Bob. "Queen Lili'uokalani—At Home: Unveiling a Statue Rich in Symbolism." *The Honolulu Advertiser* (11 April 1982): A-3.

McCamant, Peggy. "The Legacy of a Queen: Remembering Lili'uokalani." *West Hawaii Today* (18 August 1982): 26.

Ronck, Ronn. "Liliu: Getting to Know Her." *The Honolulu Advertiser* (15 April 1982): C-1, C-4.

Rubinstein, Charlotte Streifer. *American Women Artists: from Early Indian Times to Present.* Boston: G. K. Hall & Co., 1982.

1977

Goldstein, Nathan. *The Art of Responsive Drawing.* Englewood Cliffs, NJ: Prentice-Hall, 1977.

1976

Preble, Duane. *We Create Art, Art Creates Us.* San Francisco: Canfield Press, 1976.

1974

Pyle, Virginia. "Art World: The Human Form." *The Patriot Ledger* (8 October 1974): 26.

1973

Preble, Duane. *Man Creates Art Creates Man.* Rev. ed. New York: Harper and Row, 1973.

"Variety of Sculptors Guild." *Today's Art* (October 1973): 8.

1972

Kowal, Dennis and Dona Z. Meilach. *Sculpture Casting: Mold Techniques and Materials, Metals, Plastics, Concrete.* New York: Crown Publishers, 1972.

Nahu, Katherine. "Marianna Pineda: Bodies in Motion." *The Newton [MA] Times* (1 November 1972): 20.

Taylor, Robert. "Marianna Pineda Sculptures Exhibited: Survey Spans Two Decades." *Boston Evening Globe* (19 October 1972): 39.

1964

Driscoll, Jr., Edgar J. "The Art World." *The Boston Globe* (31 May 1964): A79.

1963

Swarzenski, Hans. "Recent Acquisitions of Contemporary Sculpture." *Bulletin of the Museum of Fine Arts, Boston* 61, no. 325 (1963): 96.

"The Radcliffe Institute for Independent Study." *Harvard Today* (Autumn 1963): 28.

1962

"A Sculptress With Something to Say." *Twin Citian* [Minneapolis, MN] (January 1962): 28.

1960

Driscoll, Jr., Edgar J., "Brookline Sculptress Wins: Captures Grand Prize at Boston Arts Festival." *The Boston Globe* (13 June 1960): 1, 18.

"Portfolio of Sculpture and Drawings." *Audience* [Boston, MA] (Winter 1960): 96-107.

"Recent Sculpture USA." *New York Gallery Guide* (June 1960): 8.

1958

Greer, Michael. "Home and Garden: A Decorator Speaks on Sculpture." *National Sculpture Review* 7, no. 3 (Fall 1958): 7.

1955

Kirsch, Dwight. "New Talent U.S.A.: The Upper West." *Art in America* 43, no. 1 (February 1955): 47-49.

1952

"Marianna Pineda Sculpture shown at Walker Art Center." *Minneaplois Sunday Tribune* (27 April 1952): 3.

"Sculptress' Works on Exhibition [sic]." *St. Paul's Sunday Pioneer Press* (27 April 1952): n.p.; from Marianna Pineda scrapbook.

1951

Cross, Miriam Dungan. "Show to Foster Coast Artists." *Oakland [CA] Tribune* (5 August 1951): n.p.; from Marianna Pineda scrapbook.